THE ART OF
COLOUR MIXING

Minimum colours for maximum effect,
using watercolours, acrylics, and oils

JOHN LIDZEY, JILL MIRZA,
NICK HARRIS, AND JEREMY GALTON

MAL, 10,02
Cyp

A QUINTET BOOK

Published by A&C Black (Publishers) Limited
37 Soho Square
London W1D 3DZ

ISBN 0-7136-6181-X

This book was designed and produced by
Quintet Publishing Limited
6 Blundell Street
London N7 9BH

Creative Director: Richard Dewing
Design: Sharanjit Dhol
Project Editor: Deborah Foy

Manufactured in Hong Kong by Regent Publishing Services Ltd
Printed in China by Midas Printing Ltd

Contents

About This Book

In this book we explore three popular paint mediums: acrylics, oils and watercolours, and explain how only a handful of colours, for the most part, are an adequate base from which to prepare new colours or modify existing ones. Mixing colours in any medium, be it rich, buttery oil paints or delicate, transparent watercolours produces a greater depth and variety in the finished image than does a simple reliance on manufactured colours straight from the pot or tube.

The colour palettes for each paint medium are devoted to the primary and secondary colours on the colour wheel and with browns and greys. You may find these sections useful when painting or you may prefer to use them as a basis for further experiments of your own.

Where colour mixtures are shown in this book, the proportions of the colours used to make each mixture are indicated in terms of the number of brushfuls, or parts, of colour. In many cases the colour patches show how mixing two colours together will eventually produce a third, for example, a blue added to a brown will progressively produce a grey.

The photographs of still lifes show possible subjects for the painter. The main colours in each set-up are analysed in terms of their constituent colours, and an appropriate breakdown is shown alongside indicating the proportions of each colour used. Further practise can be gained by taking a colour photograph from a magazine and matching the colours in a similar way.

The Gallery sections dissect a particular artist's work in terms of its colour components, the effects of light and shadow, and key tips on how to recreate special painterly effects in your own work.

If you base your mixings on those in the following pages you may not be able to match exactly the resulting colours with the ones shown. This could be because of a difference in the manufacturer or grade of paint you use, the nature of the paper you use or even the kind of light under which you view comparisons. However, the colour patches shown should give you a completely satisfactory guide to the results you can expect.

Happy mixing!

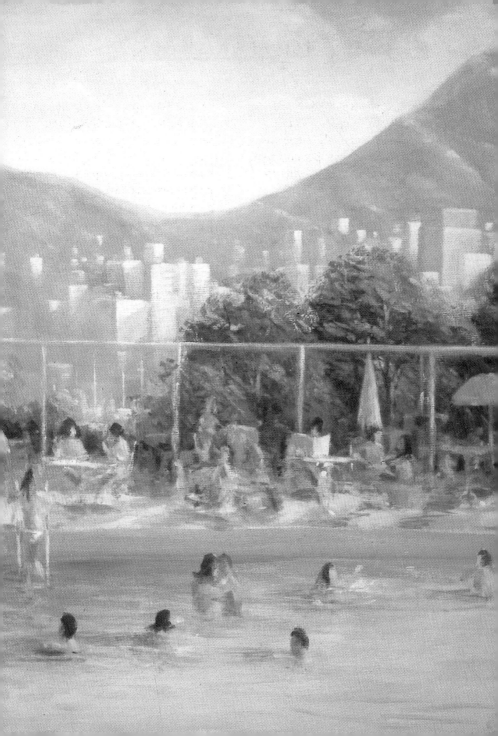

AN INTRODUCTION TO COLOUR THEORY

A little colour theory goes a long way and is essential for successful colour mixing in any medium. Each colour you choose to use has three different qualities. These are hue, value and saturation.

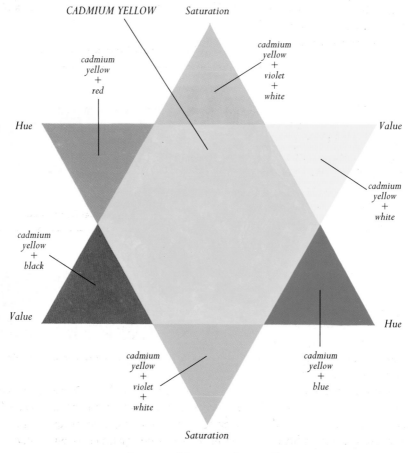

CADMIUM YELLOW

Saturation

*cadmium
yellow
+
violet
+
white*

*cadmium
yellow
+
red*

Hue

Value

*cadmium
yellow
+
white*

*cadmium
yellow
+
black*

Value

Hue

*cadmium
yellow
+
violet
+
white*

*cadmium
yellow
+
blue*

Saturation

Three ways of changing cadmium yellow.

HUE

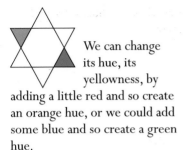

We can change its hue, its yellowness, by adding a little red and so create an orange hue, or we could add some blue and so create a green hue.

Hue. Changes of hue from orange to green.

VALUE

We can change its lightness or dark- ness, or its value, by adding white or black. If we add white we make a cream colour. Adding black creates a kind of green.

Value. Changes of value from dark to light.

SATURATION

Thirdly, we can also alter the brightness or dullness of a colour. Cadmium yellow, for example, is a very bright colour, but we cannot add anything to make it more saturated. However, we can of course make it duller. It can be made greyer just by adding a little violet.

Saturation. Changes of saturation from dull to light.

Real familarity with these ideas helps you to re-create in your painting any colour you are looking at. It just needs to be thought of in terms of these three qualities, of hue, value and saturation.

COLOUR HUE

Here is a colour wheel showing the six main colours. In theory all colours derive from the three primary colours, red, yellow and blue. The three secondary colours, orange, green and violet are the result of mixing the primary colours, so that red and yellow make orange, yellow and blue make green, and red and blue make violet.

Two especially important things should be noted about the colour wheel. The colours that are directly opposite each other are called complementary colours. We will be paying a lot of attention to these later. Blue and orange are complementary colours, red and green are and so are yellow and violet.

The second very important thing is to notice that the visual gaps between the colours are not equal. You can see that it is a only one small step from blue to violet, but from yellow to green there is clearly a greater perceptible distance.

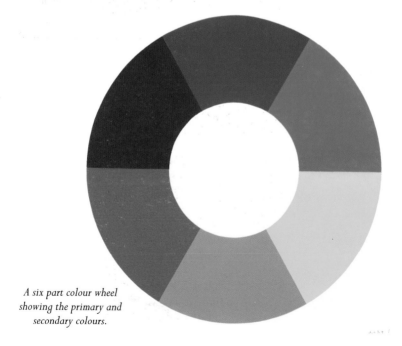

A six part colour wheel showing the primary and secondary colours.

PRIMARY COLOURS	SECONDARY COLOURS
blue	green
red yellow	violet orange

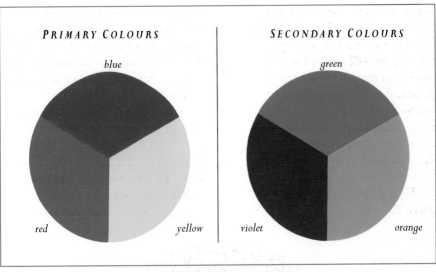

There is a much greater visual gap between yellow and green than there is between blue and violet.

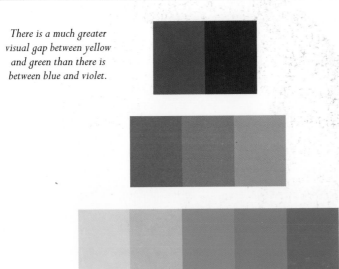

COLOUR VALUE

We have seen that colour value is in effect its lightness or darkness. Violet is certainly much darker than yellow. The best way to become conscious of this is to try to relate the colours to an equivalent grey. We can clearly see just how different yellow and violet are by looking at the tone gradation chart. To mix a violet of the same value or tone as yellow is going to take a lot of white.

It is mainly by being able to control the value of the colours you use that you gain the possibility of developing a convincing sense of space and depth in your paintings.

TINTS

If we add white to a colour or lighten it we are making a tint. For example, pink is a red tint.

SHADES

If we add black to a colour or darken it we are making a shade. For example, brown is an orange shade.

Using titanium white to makes tints of deep violet.

Using Payne's grey to make shades of yellow ochre.

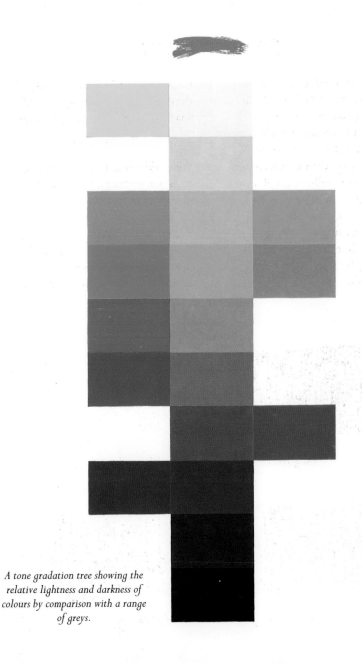

A tone gradation tree showing the relative lightness and darkness of colours by comparison with a range of greys.

COLOUR SATURATION

In the previous section we saw how hues can be thought of in terms of their lightness or darkness. On the value chart we can see that cadmium red is equivalent to a mid-grey. To demonstrate the nature of colour saturation we can move the red by stages towards its equivalent value grey, reducing and then extinguishing its brightness as we go.

In this painting it can be seen how the colours have all been reduced in their brilliance to create subtle harmonies. The phthalo green of the wall and the cadmium yellow deep of the road show this very well.

When we make these tints by adding white to these desaturated colours we create a whole range of colours in the wall and the road.

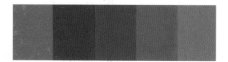

Cadmium red reducing in brightness towards an equivalent grey.

A mix of phthalo green and white losing its brilliance.

Cadmium yellow deep becoming desaturated.

Tints of desaturated phthalo green.

Tints of desaturated cadmium yellow deep.

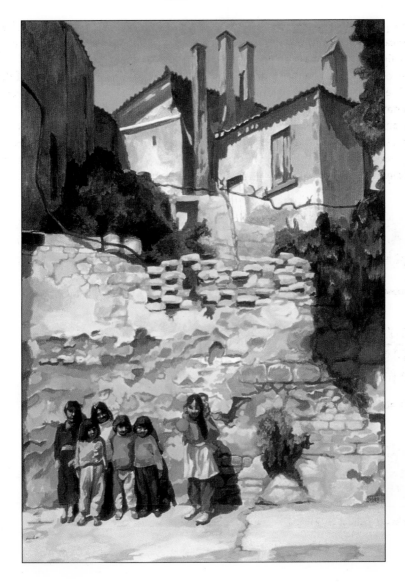

ACRYLICS

Acrylics are really exciting to paint with and are ideal for learning about mixing colours, from the very bright to the subtlest, as they have just the right qualities to help you make rapid and sure progress.

Acrylic paints use the same pigments as oil paints or watercolours, but (to be technical for a moment) they are bound in a synthetic medium – a transparent water emulsion of acrylic polymer resin. As a result acrylic paints have qualities that set them apart. They will not go yellow, or go mouldy or brittle for instance and they are very flexible.

You mix acrylic with water to paint with it. This makes it very easy to use. It dries rapidly, by evaporation, and is waterproof once it is dry. As it is no longer water-soluble when dry you can add more to your painting without damaging the paint surface, and you do not have to wait for days to do so.

One of the great qualities of acrylic paint is that it is very versatile, since it can be used as very thick paint or as very thin. You can use it straight from the tube and create thick impasto paintings, like oil, or you can dilute it with water to a very thin consistency, so that you can apply it in washes on paper, like watercolour.

Another characteristic of acrylic paint and one that is really valuable in terms of colour mixing is that all the colours in a manufacturer's range are fully compatible with each other and so can be mixed together without any worry at all.

With other types of paints there can be many things to worry about, as oil painters and watercolourists will know, but painting with acrylics really has very few "don'ts". There is one that must be mentioned however–the twin qualities of quick drying time and insolubility mean you must not let paint dry on your brush!

RIGHT Mixing colours – from light to dark and from bright to subtle.

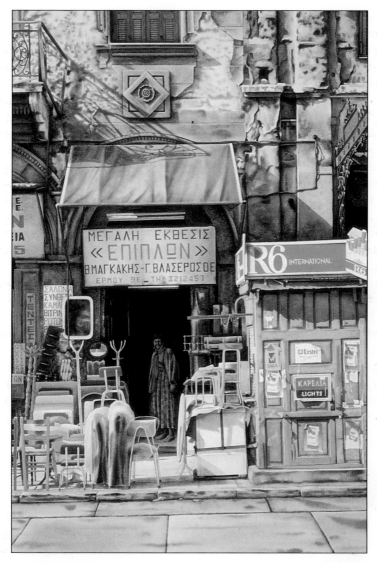

EQUIPMENT

You do not need a great deal of equipment to follow these lessons and exercises in mixing acrylics, but there are some things which are essential.

TYPES OF PAINT

It is probably best to stick to one manufacturer's range of paints. There are two forms of acrylics available.

BELOW Many types of brush are suitable for acrylics.

The Standard formula, which has a buttery consistency similar to oil colour, is suitable for most techniques, including impasto. Flow formula is much runnier and is good for painting large flat areas and wet into wet. Both are fully intermixable and you can choose whichever you prefer.

MEDIUMS

A number of different mediums and varnishes can be used in conjunction with acrylic and which you might find useful for painting, but they are not essential or necessary for learning about mixing. The one medium which is essential is water.

WHAT TO PAINT ON

Almost any painting surface is suitable for acrylics: canvas, board, card or paper. When learning how to mix paints a fairly thick white paper is probably best.

BRUSHES

Again, almost any type of brush is suitable for acrylics but we suggest you use round, watercolour-type brushes made with synthetic hair if you are going to work on paper, but if you would rather do so, you could

RIGHT Ceramic dishes are excellent for mixing acrylic paints.

perfectly well use oil-style bristle brushes. Keep your brushes clean by washing them in warm soapy water before the paint dries.

PALETTE

You will need a surface on which to mix your paints. This needs to be a hard gloss surface. Glass and ceramic surfaces are particularly useful. The best way to clean your mixing surface is to let the paint dry and then soak the palette in warm soapy water. After a minute or two the paint will easily peel off.

THE STARTER PALETTE

The art of sucessful colour mixing is to be able to create the maximum colour range from a minimum number of paints. A manufacturers range can easily number over 70 colours. Each one will have its own special qualities, but the important thing when selecting your palette is to have a balance – a group of colours that is evenly distributed.

We have used a relatively small number of colours in the exercises in this book, as it is possible to learn far more initially from using a small group of colours extensively. For our purposes we want to begin with the most vivid colours available, because every time you mix colours the result loses some brightness.

Using just the eight colours plus a black and a white featured in the illustration you can discover much of

what you need to know. By the way, despite its name, Payne's grey is really a black and "phthalo" is also known as phthalocyanine.

As your awareness increases and your painting needs become greater you will almost certainly want to expand your palette and the six additional colours illustrated are suggestions. Please remember they are only suggestions, as everybody will have their own favourites. In this book we have also used a number of other colours.

Remember that you are likely to use white far more than anything else, and finally, do try to avoid mixing more than three colours at a time, because if you do it is very likely that you will end up with lifeless colours. (There are almost limitless ways of mixing mud).

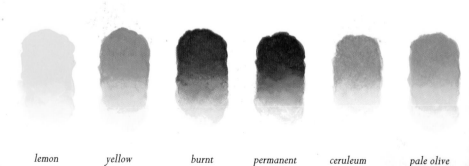

| lemon yellow | yellow ochre | burnt sienna | permanent violet | ceruleum | pale olive green |

SUGGESTED STARTER PALETTE

cadmium orange

cadmium red

cadmium yellow

Payne's grey

phthalo green

permanent rose

titanium white

phthalo blue

deep violet

ultramarine

MIXING BLUE

Two very useful blues are ultramarine and phthalo blue. Ultramarine is the "warmer" of the two, being slightly more violet while phthalo blue is "cooler" and veers slightly towards green. It can be seen when mixing with white that colours have different strengths. Ultramarine does not retain its intensity as much as phthalo blue. Other blues which are of great interest are cobalt blue, which is a pure colour, leaning neither to green or violet and cerulean, a delicate light blue.

By moving equally either side of blue and mixing turquiose and violet you will create a blue which is much less bright.

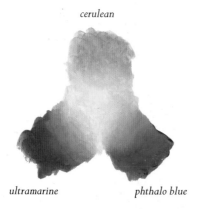

cerulean

ultramarine *phthalo blue*

Cerulean blue, ultramarine, phthalo blue, and titanium white

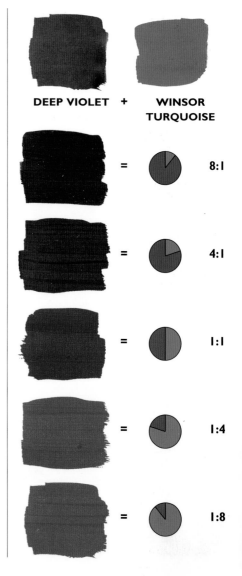

DEEP VIOLET + **WINSOR TURQUOISE**

= 8:1

= 4:1

= 1:1

= 1:4

= 1:8

PHTHALO BLUE	+	**TITANIUM WHITE**	**ULTRAMARINE** +	**TITANIUM WHITE**

 = 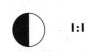 1:1 = 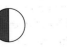 1:1

 = 1:2 = 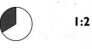 1:2

 = 1:4 = 1:4

 = 1:8 = 1:8

 = 1:16 = 1:16

STILL LIFE – BLUE

In this still life you find a range of blues from violet blues to green blues. When mixing very dark blues you maintain the richness of colour by mixing different blues together, sometimes adding a touch of another colour such as permanent rose or phthalo green.

1 Payne's grey
2 ultramarine
4 phthalo blue

1 phthalo blue
12 titanium white

1 ultramarine
6 titanium white

1 permanent rose
3 phthalo blue
9 titanium white

When white is added ultramarine loses its intensity. To achieve a vivid blue you can paint washes of pure colour over a light background. For example, for best results when painting the bottle it can be under-painted with strongly contrasted lights and darks and then glazed thinly over with ultramarine.

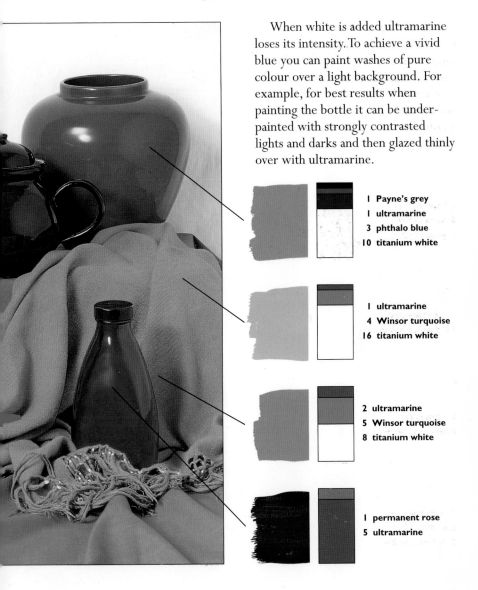

1 Payne's grey
1 ultramarine
3 phthalo blue
10 titanium white

1 ultramarine
4 Winsor turquoise
16 titanium white

2 ultramarine
5 Winsor turquoise
8 titanium white

1 permanent rose
5 ultramarine

GALLERY – BLUE

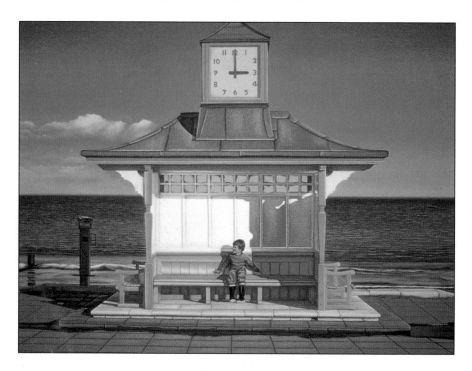

Palette – titanium white, cadmium orange, cadmium red, deep violet, phthalo blue, phthalo turquoise, Payne's grey

Using only phthalo blue modified by other colours to paint this picture a suprising number of blue mixes have been achieved. Phthalo turquoise has been added to create a greener blue in the sea and deep violet has also been added, for example. Touches of deep violet with white make the blue shadows in the building warmer. Notice how the sky is a deep blue at the top and fades away to a very pale blue at the horizon as the result of very controlled graduated mixing.

Phthalo blue, titanium white and deep violet mix together to make a warm blue.

MIXING SEA COLOURS

Here are some alternative colours to use when painting sea: ultramarine, cerulean blue and phthalo green with titanium white.

MIXING GREEN

There are so many ways of successfully mixing green in acrylics that you are spoilt for choice. It is a good idea to take only a small set of colours and explore the potential. Remember, if you use a blue like ultramarine which is slightly violet and a yellow which is slightly orange, the green you end up with will be very much more restrained than one mixed with a green-biased blue or a sharp yellow, when the result will really sing.

Don't forget that you are going to use much more yellow than blue in your mixtures (unless you want a very blue green) so add blue to yellow and not the other way around or you are likely to waste a lot of paint.

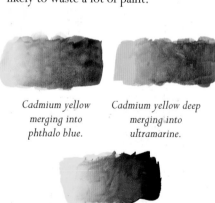

Cadmium yellow merging into phthalo blue.

Cadmium yellow deep merging into ultramarine.

Cadmium yellow pale merging into Payne's grey.

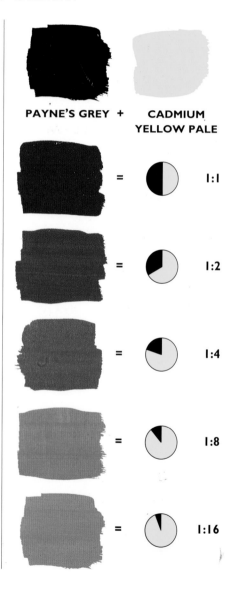

PAYNE'S GREY + CADMIUM YELLOW PALE

= 1:1

= 1:2

= 1:4

= 1:8

= 1:16

| **PHTHALO BLUE** | + | **CADMIUM YELLOW** | | **ULTRAMARINE** | + | **CADMIUM YELLOW DEEP** |

 = 1:2 = 2:1

 = 1:4 = 1:1

 = 1:8 = 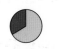 1:2

 = 1:16 = 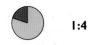 1:4

 = 1:32 = 1:8

STILL LIFE – GREEN

While there are many variations of green in this still life group, there are some blue greens which are not usually found in nature, where it is normally yellow greens which predominate. When white is added to a blue-biased green, such as phthalo green, the colour becomes very strong.

1 Payne's grey
1 phthalo green
2 cadmium yellow
6 titanium white

1 cadmium yellow
1 phthalo blue
1 Payne's grey

1 phthalo green
10 titanium white

1 Payne's grey
6 cadmium yellow

Notice that many yellows such as the cadmiums and Payne's grey make an opaque green, while some colours straight from the tube, such as bright green or pale olive green are very transparent.

When mixing green from blue and yellow the colour will be affected by the orangeness of the yellow.

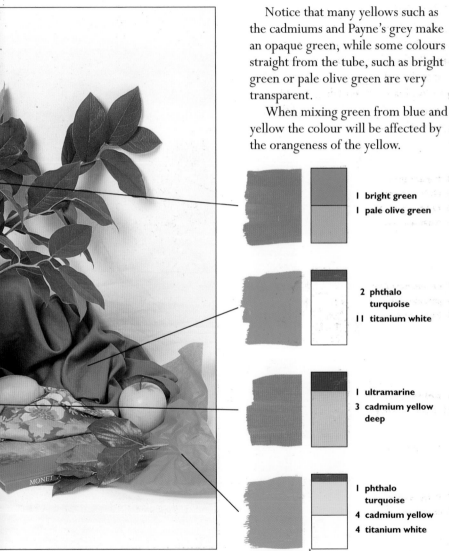

1 bright green
1 pale olive green

2 phthalo turquoise
11 titanium white

1 ultramarine
3 cadmium yellow deep

1 phthalo turquoise
4 cadmium yellow
4 titanium white

GALLERY – GREEN

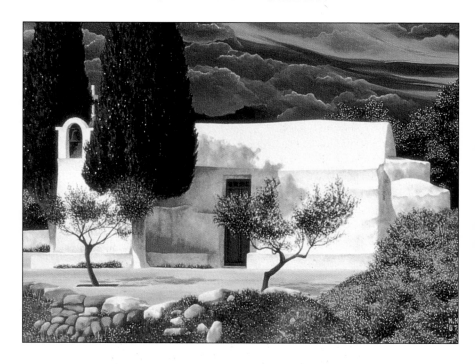

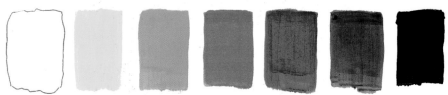

*Palette – titanium white, cadmium yellow, cadmium orange,
cadmium scarlet, phthalo green, phthalo blue, Payne's grey*

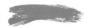

In the picture another way of mixing colour is demonstrated. This is a method where small dots of colour are applied and tonal and colour changes take place on the paper or canvas as the dots build up. This is a very good way of painting foliage, although it can be quite difficult. Acrylics are suitable for this because the paint dries so quickly and it is possible to build up the surface rapidly. It is advisable to start by applying the mid tones, followed by the dark areas and finally the highlights.

Here cadmium yellow, phthalo green, and cadmium red mix together to make an olive green

MIXING FOLIAGE COLOURS

An example of a "pointillist" method of applying colour. The bushes on the right of the picture are painted using this method.

MIXING YELLOW

Despite the appearance of being very brash, yellow is really a very sensitive colour. It is easy to sully yellow because small amounts of other colours will alter its character dramatically. Green or red, for instance, will retain their greenness and redness much more. A trace of blue will turn a yellow into green and similarly a hint of red will turn it into orange. Consequently it is very important that when mixing with yellow you add other colours to it and not the other way round.

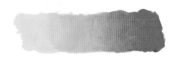

Cadmium yellow merging into permanent rose.

A mix of the two, eight parts yellow and one part rose.

Cadmium yellow merging into phthalo green.

A mix of the two, eight parts yellow and one part green.

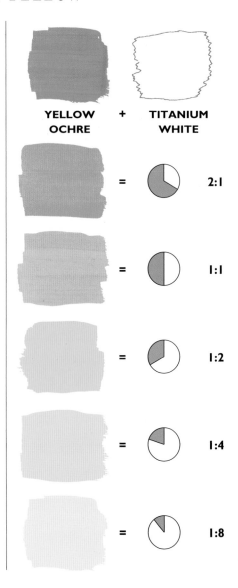

RAW SIENNA	**+**	**CADMIUM YELLOW PALE**	**CADMIUM YELLOW**	**+**	**TITANIUM WHITE**

 = 2:1 = 4:1

 = 1:1 = 1:1

 = 1:2 = 1:4

 = 1:4 = 1:16

 = 1:8 = 1:64

STILL LIFE – YELLOW

This glowing still life group of natural and man-made objects features many strong yellows and many dark yellows. The predominant colour here is cadmium yellow deep. For the flowers, cadmium yellow used straight from the tube would be the most suitable colour, as they are slightly paler than the surrounding objects.

I **cadmium yellow deep**
I **permanent violet**

I **lemon yellow**
2 **cadmium yellow**
6 **titanium white**

I **cadmium yellow deep**
I **cadmium yellow**
4 **titanium white**

I **deep violet**
2 **cadmium yellow deep**
4 **cadmium yellow**

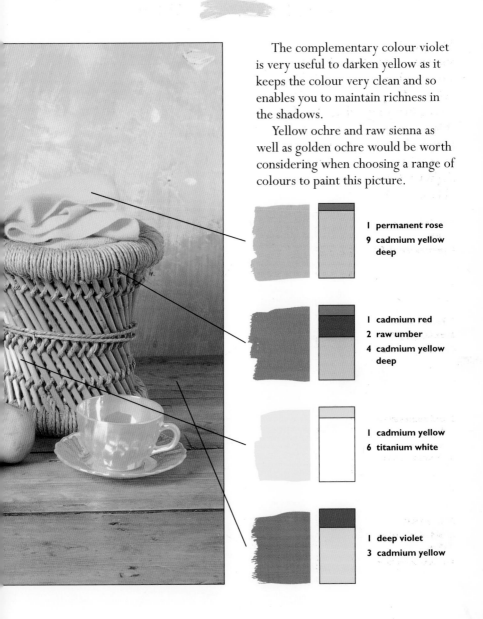

The complementary colour violet is very useful to darken yellow as it keeps the colour very clean and so enables you to maintain richness in the shadows.

Yellow ochre and raw sienna as well as golden ochre would be worth considering when choosing a range of colours to paint this picture.

1 permanent rose
9 cadmium yellow deep

1 cadmium red
2 raw umber
4 cadmium yellow deep

1 cadmium yellow
6 titanium white

1 deep violet
3 cadmium yellow

MIXING ORANGE

A true yellow such as cadmium yellow and a true red such as cadmium red give a fresh clean range of orange, while more earthy colours in the range can be produced if the mixture is made with burnt sienna. Cadmium orange itself, when tinted with white, creates a delightful range of tangerine colours. With the addition of yellow ochre for instance, these can form the base for a variety of light skin tones. Carefully adding Payne's grey to orange takes us by degrees into the brown range of colours.

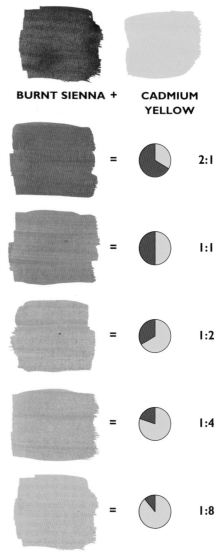

BURNT SIENNA + **CADMIUM YELLOW**

= 2:1

= 1:1

= 1:2

= 1:4

= 1:8

Moving from cadmium yellow to cadmium red.

Mixes of cadmium orange, yellow ochre and titanium white

CADMIUM RED + DEEP	CADMIUM YELLOW		CADMIUM ORANGE +	TITANIUM WHITE

 = 1:1

 = 1:1

 = 1:2

 = 1:2

= 1:4

 = 1:4

 = 1:8

 = 1:8

 = 1:16

 = 1:16

 = 1:16

MIXING RED

As you move round the colour circle from red in either direction it becomes more orange on the one hand, more violet on the other. Cadmium red as a pure red, cadmium scarlet as a lighter more orange red, and cadmium red deep as a darker more violet red cover this area extremely well.

Mixing red with white produces pink of course. You will find that the cleanest and most delicate of pinks can be obtained with permanent rose and titanium white. Mixing the cadmium reds with black or Payne's grey produces rich warm browns.

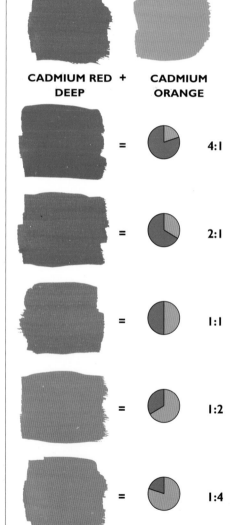

CADMIUM RED + CADMIUM DEEP **CADMIUM ORANGE**

= 4:1

= 2:1

= 1:1

= 1:2

= 1:4

Delicate rose pinks made from titanium white added to permanent rose.

CADMIUM RED + **TITANIUM WHITE** **DEEP VIOLET** + **CADMIUM SCARLET**

 = 1:1 = 2:1

 = 1:2 = 1:1

 = 1:4 = 1:2

 = 1:8 = 1:4

 = 1:16 = 1:8

GALLERY – RED

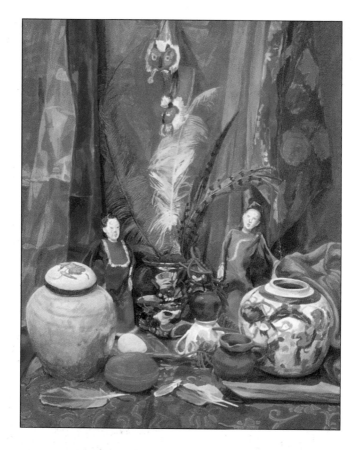

*Palette – titanium white, cadmium yellow, cadmium orange,
cadmium red, cadmium red deep, permanent rose, ultramarine,
phthalo blue, phthalo green, Payne's grey*

Basically the starter palette suggested on page 19 was used in this picture with one or two additions. The challenge when using red is to keep the richness and brilliance of the

How permanent rose, cadmium red and phthalo green mix together to make a good shadow colour.

colour even in the shadow areas and in the very light areas. The reds are mixed together where possible to give them resonance. The blues, deep violet and phthalo green were used in the shadows, while in some cases yellow, rather than white, was used to lighten the red.

Since pink is the result when white is added to red it is often helpful to give a final thin wash of red to unify an area. In the picture illustrated, this can be seen in the hanging fabric and in the pink scarf on the right.

MIXING THE SHADOW COLOURS

This shows how to use colours other than red to create lively shadow areas. A pink wash was used over the highlights.

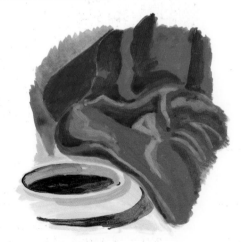

MIXING VIOLET

A lovely clear violet can be made with permanent rose and ultramarine. Beacause many reds and many blues do not have the appropriate characteristics it can often be very difficult to create a strong bright violet, the results can often be dull. It is therefore important to have a colour like deep violet as part of your palette; it makes a beautiful lilac when mixed with white. As violet is the darkest of the primary and secondary colours the range of tints that can be mixed is wide.

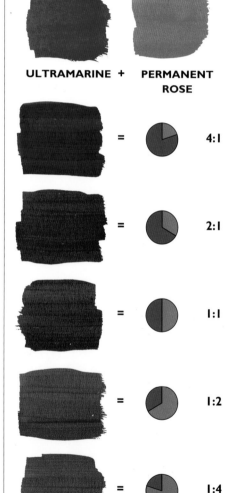

ULTRAMARINE + PERMANENT ROSE

= 4:1

= 2:1

= 1:1

= 1:2

= 1:4

From cool blue violet to warm red violet with ultramarine, deep violet and permanent rose, modified by titanium white.

ULTRAMARINE + **CADMIUM RED DEEP** **DEEP VIOLET +** **TITANIUM WHITE**

 = 4:1 = 1:1

 = 2:1 = 1:2

 = 1:1 = 1:4

 = 1:2 = 1:8

 = 1:4 = 1:16

MIXING YELLOW / VIOLET

Complementary colour mixes form the next three sections. Yellow and purple are the most distant from each other in terms of lightness and darkness. Being opposite each other on the colour circle they tend to neutralize each other when mixed and a range of desaturated colours is created.

The exercises here show the possibilities available with deep violet and cadmium yellow deep (cadmium yellow with a little cadmium orange in effect). You can do similar exercises with other yellows and violets to see just how delicate the outcomes can be.

Moving from lemon yellow to deep violet.

A mix of the same colours with the addition of titanium white in the ratio of 1:1:1.

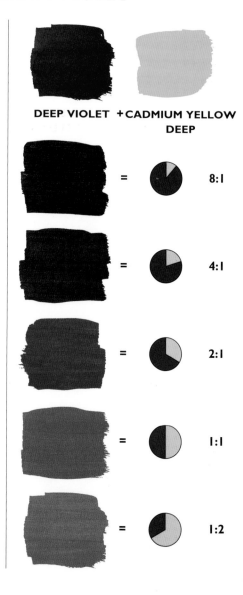

DEEP VIOLET + CADMIUM YELLOW DEEP

= 8:1

= 4:1

= 2:1

= 1:1

= 1:2

DEEP VIOLET	+ TITANIUM WHITE	+ CADMIUM YELLOW DEEP		DEEP VIOLET	+ TITANIUM WHITE	+ CADMIUM YELLOW DEEP

 = 1:2:3

 = 3:4:1

 = 1:4:3

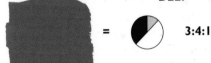 = 3:8:1

 = 1:8:3

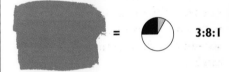 = 3:16:1

 = 1:16:3

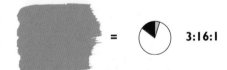 = 3:32:1

 = 1:32:3

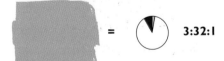 = 3:64:1

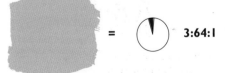

GALLERY – YELLOW / VIOLET

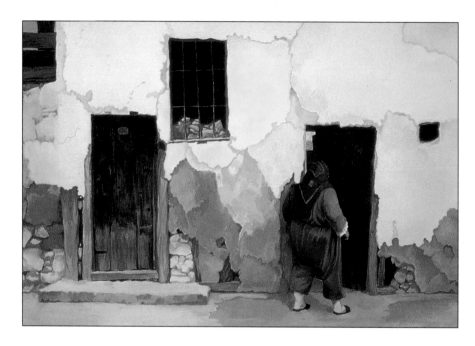

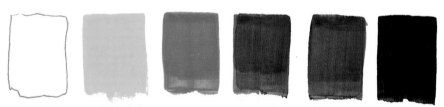

*Palette – titanium white, cadmium yellow deep, cadmium red deep,
deep violet, phthalo blue, Payne's grey*

This picture was underpainted with a thin wash of cadmium yellow. The colours most used were cadmium yellow deep and deep violet. By mixing these two colours together in changing ratios that steadily move from mostly yellow to mostly violet, the neutral colours created are lively and the picture remains harmonious and balanced.

The addition of cadmium red and phthalo blue to deep violet modifies the colour, as in the shadows of the woman's trousers.

Phthalo blue and deep violet mix with cadmium red to create variations of dark violet.

MIXING COLOURS BY GLAZING

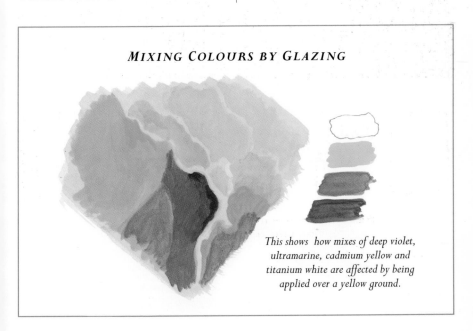

This shows how mixes of deep violet, ultramarine, cadmium yellow and titanium white are affected by being applied over a yellow ground.

MIXING RED/GREEN

Red and green combine to give a whole host of colours found in trees and wood, leaves, foliage and grasses, as well as in the brickwork of buildings. Consequently they are central to a great many landscape paintings. Here we have chosen three different reds to mix with three different greens in order to give some indication of the possibilities available. You can see clearly how these colours not only lose a lot of their brightness when mixed, but also how they make much darker colours as well.

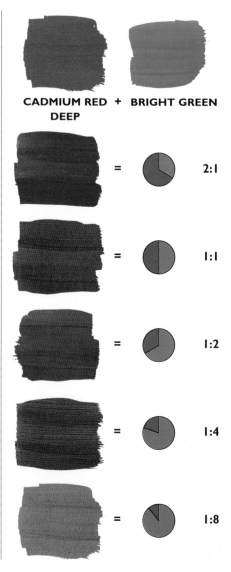

CADMIUM RED DEEP + BRIGHT GREEN

= 2:1

= 1:1

= 1:2

= 1:4

= 1:8

Two further colours mixed together, pale olive green and permanent rose.

Bright green merging with cadmium red.

CADMIUM SCARLET	**+**	**WINSOR TURQUOISE**		**CADMIUM RED** + **PHTHALO GREEN**

 = 4:1

 = 8:1

 = 2:1

 = 4:1

 = 1:1

 = 2:1

 = 1:2

 = 1:1

 = 1:4

 = 1:2

STILL LIFE – RED/GREEN

Apart from creating a bold colour balance, this still life contains many objects whose colours illustrate what happens when red and green are mixed together, creating a range of drab greens and dark reds that beautifully demonstrate the subtleties of complementary colour mixtures.

1 **bright green**
6 **permanent rose**

1 **Mars black**
3 **cadmium yellow deep**
10 **cadmium red deep**

1 **cadmium red**
1 **phthalo green**
2 **permanent rose**

1 **cadmium red**
1 **bright green**
2 **permanent rose**

Olive greens, for example, are obtained by mixing red with yellow greens. Rich dark greens can be made by adding small amounts of blue reds to green.

Deep burgundy reds are mixed by combining blue reds, such as permanent rose, with blue greens.

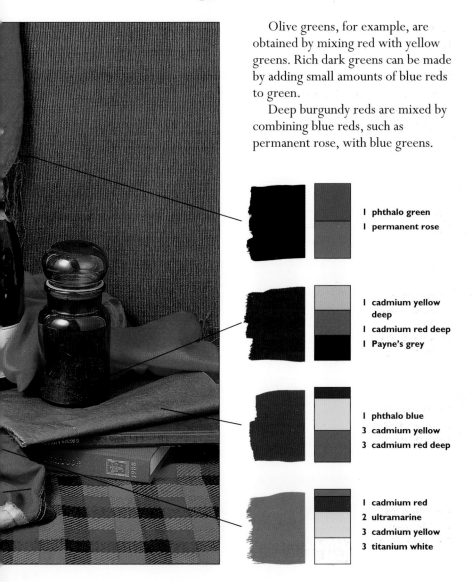

1 phthalo green
1 permanent rose

1 cadmium yellow deep
1 cadmium red deep
1 Payne's grey

1 phthalo blue
3 cadmium yellow
3 cadmium red deep

1 cadmium red
2 ultramarine
3 cadmium yellow
3 titanium white

MIXING BLUE/ORANGE

The third pair of complementary colours explored here looks at cadmium orange being mixed with three different blues. Though phthalo blue is as strong a colour, you will find that cadmium orange has more colour strength than many blues. This is particularly noticeable with cerulean blue which has to be used in large quantities before it has much effect. It is a very transparent colour and so is extremely useful for an overpainting or glazing technique to alter an orange undercolour.

If you do some mixing exercises based on other pairs of complementary colours such as yellow green and red violet you will find that a fascinating colour world will be revealed.

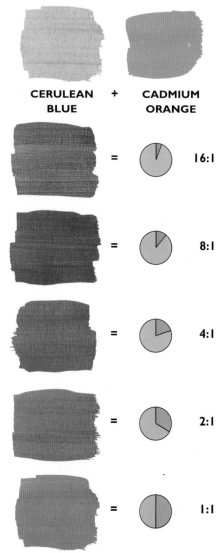

CERULEAN BLUE + **CADMIUM ORANGE**

= 16:1

= 8:1

= 4:1

= 2:1

= 1:1

Cadmium orange as a base colour with an overlay of cerulean blue.

PHTHALO + TITANIUM + CADMIUM
BLUE WHITE ORANGE

 = 3:2:1

 = 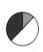 3:4:1

 = 3:8:1

 = 3:16:1

 = 3:32:1

ULTRAMARINE + CADMIUM
ORANGE

 = 8:1

 = 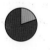 4:1

 = 2:1

 = 1:1

 = 1:2

GALLERY – BLUE/ORANGE

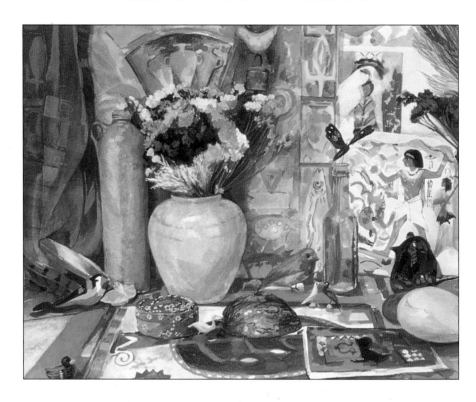

Palette – titanium white, cadmium yellow deep, cadmium orange, permanent rose, deep violet, phthalo blue, phthalo green, Payne's grey

Using the complementary colours blue and orange as the basis of a picture makes it a vibrant and well balanced painting in terms of colour. Throughout the painting they are used in almost every object depicted to mix, sometimes with other colours, many variants. Many greys and browns, as well as desaturated oranges and blues, are the result. As well as cadmium orange, a mix of cadmium yellow deep and permanent rose are used. Tiny amounts of blue added to the orange darken the colour without changing the nature of it too much.

Cadmium orange, phthalo blue and titanium white make a fawn mix which is used throughout the painting.

USING TRANSPARENT COLOURS

Here we can see how orange and blue are affected by a transparent wash of phthalo blue.

MIXING BROWN

Brown is essentially a dark orange or a dark red and so the colours used to mix it must include colours from the warm sector of the colour circle from yellow orange through to red violet. Using red rather than orange creates a warmer result, while a rich dark brown can be obtained by mixing red and black. To obtain lighter browns you can add extra yellow, and white added makes fawn or beige. The earth colours such as burnt umber and burnt sienna are very useful.

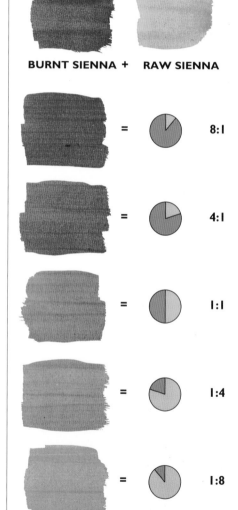

BURNT SIENNA + RAW SIENNA

= 8:1

= 4:1

= 1:1

= 1:4

= 1:8

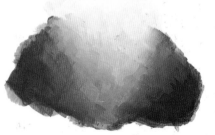

A three part mixture of titanium white, burnt sienna and burnt umber.

PAYNE'S GREY + CADMIUM RED	**PAYNE'S GREY + CADMIUM ORANGE**

 = 1:1 = 1:1

 = 1:2 = 1:2

 = 1:4 = 1:4

= 1:8 = 1:8

 = 1:16 = 1:16

STILL LIFE – BROWN

It is possible to use manufactured browns, such as raw umber, burnt umber and burnt sienna, but exciting brown mixtures can be achieved in many different ways. In this still life we have objects of warm terracotta and of earth colours and dark reflective surfaces as well.

1 **permanent violet**
2 **cadmium orange**

2 **Mars black**
3 **cadmium red deep**

1 **cadmium yellow**
2 **burnt sienna**
3 **permanent rose**

1 **Mars black**
14 **burnt sienna**

The browns range from very hot orange browns to the cool grey brown found in the pine cone, which can be made by mixing raw umber and titanium white. Suprisingly a mixture of Mars black and cadmium red deep makes a very rich brown which can be used in the very dark areas.

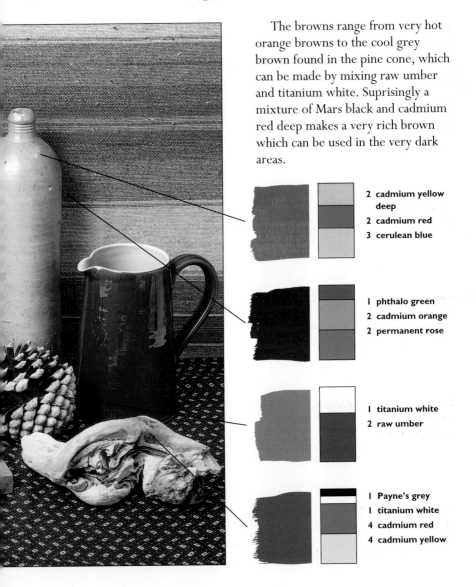

2 cadmium yellow
 deep
2 cadmium red
3 cerulean blue

1 phthalo green
2 cadmium orange
2 permanent rose

1 titanium white
2 raw umber

1 Payne's grey
1 titanium white
4 cadmium red
4 cadmium yellow

GALLERY – BROWN

*Palette – titanium white, cadmium yellow deep, cadmium orange,
cadmium red deep, phthalo turquoise, Payne's grey*

Given the number of colours that can be used to make brown, the palette used here is fairly limited. The painting has a range from yellow browns to grey browns showing that it is possible to achieve a good selection of brown mixtures with a few colours. The picture was built up using watered down paint, one colour laid in transparent washes over the other. The dark areas are built up, allowing the colours underneath to show through, so that the mixtures can be gradually altered as the painting develops.

Phthalo turquoise, cadmuim red deep and Payne's grey make a rich dark brown.

MIXING A RANGE OF BROWNS

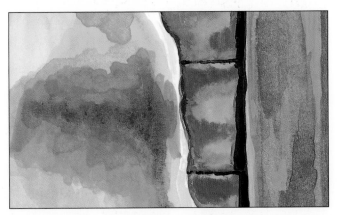

All the colours in the chosen palette were used to make the mixtures of brown shown here.

FROM WHITE TO GREY

Everybody knows that you can easily produce grey by mixing black and white, but for a painter there are far more interesting possibilities. Successful mixing of grey depends upon an awareness of which colours are complementary. Ultramarine and cadmium orange, cadmium yellow and deep violet, cadmium red and phthalo green, for example, all produce beautiful greys when mixed with white. There are many other combinations and you might like to find some of them, but in all cases extremely well-controlled mixtures are needed and it is essential to pay a lot of attention to the ratios involved (often in the region of 3:1 + white).

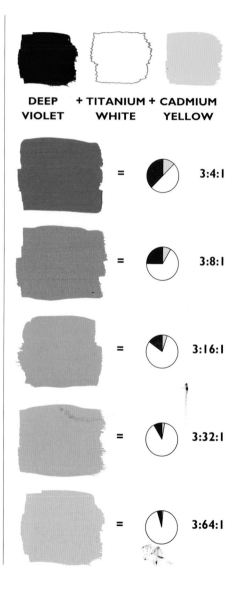

DEEP VIOLET + **TITANIUM WHITE** + **CADMIUM YELLOW**

= 3:4:1

= 3:8:1

= 3:16:1

= 3:32:1

= 3:64:1

Shades of grey made with titanium white and Mars black.

Shades of grey made with titanium white and Payne's grey.

ULTRA-MARINE **+ TITANIUM WHITE** **+ CADMIUM ORANGE**

CADMIUM RED **+ TITANIUM WHITE** **+ PHTHALO GREEN**

 = 3:4:1

 = 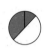 3:4:1

 = 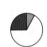 3:8:1

 = 3:8:1

 = 3:16:1

 = 3:16:1

 = 3:32:1

 = 3:32:1

 = 3:64:1

 = 3:64:1

STILL LIFE – WHITE/GREY

When mixing greys and whites it is worth observing carefully the nature of the colour. Does it perhaps have a bluish tinge or is it a greenish grey? A touch of yellow or red can enliven a rather dull grey and make it warmer. Dark greys made from a basic mixture of black and white can be made much richer by adding a little violet or blue.

1 Payne's grey
1 deep violet
1 titanium white

1 deep violet
2 cadmium yellow deep
24 titanium white

1 cadmium orange
2 phthalo blue
2 Payne's grey
24 titanium white

3 cerulean blue
8 titanium white
trace cadmium red
trace cadmium yellow

Mixing modified whites with the addition of colour to change its nature slightly has to be done with great care. It is better to add tiny touches of paint as it is easy to overdo the amount of added colour. When it has been handled sucessfully a painting which has explored different whites can be very rewarding.

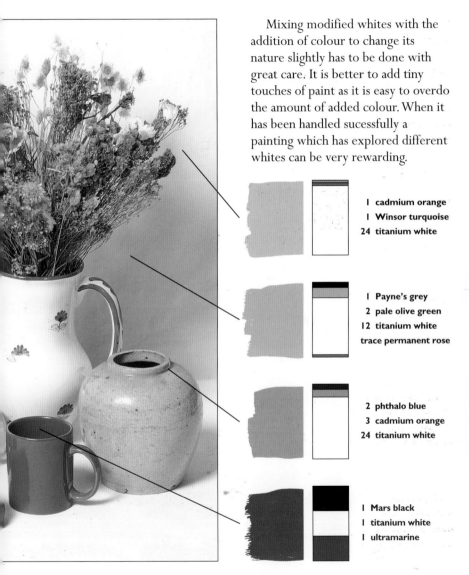

1 cadmium orange
1 Winsor turquoise
24 titanium white

1 Payne's grey
2 pale olive green
12 titanium white
trace permanent rose

2 phthalo blue
3 cadmium orange
24 titanium white

1 Mars black
1 titanium white
1 ultramarine

OILS

To be confronted by row upon row of oil paint tubes in a local art shop can be confusing enough for the seasoned artist and positively daunting to the beginner. What are they all used for? Why are there so many colours when it is obviously impractical to own the complete range? This section is designed to show you which oils are essential and to demonstrate that, for most puposes, only a handful of tube colours are really necessary.

The colour palettes that follow show just some of the ways in which colours can be modified or new ones created solely by mixing paints. Primarily with the figurative painter in mind, this section shows how some of the colours found in a series of arranged still lifes can be mixed using key oils.

Throughout the section the approximate proportions of the tube colours that were used to make each mixture are indicated. Bear in mind that paints made by different manufacturers have different strengths and you may find that these proportions vary somewhat.

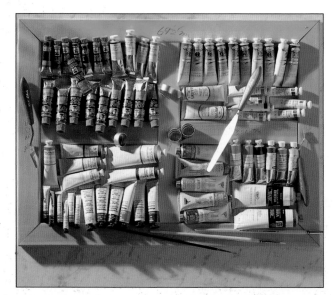

RIGHT
The range of tube colours available in art shops is vast.

EQUIPMENT AND MIXING COLOUR

Ideally mixing should be done with a palette knife, its size chosen according to the amount of paint involved. For fast work such as a landscape on location it is more convenient to use brushes for mixing, although they do become worn much more quickly, especially the more expensive sable brushes. Those brushes with synthetic fibres should never be used to mix paints since any rotary action quickly and irreversibly twists the fibres out of shape.

Paint can be used straight out of the tube or it can be thinned with a painting medium. A good tip is to use a mixture of two-thirds pure turpentine with one third refined linseed oil. This gives a fairly glossy appearance once the paint is dry. Brushes should be cleaned with oil of turpentine.

To mix a particular colour in, say, a still life, it can be a help to isolate it from its surroundings by viewing it through a small hole either cut in a piece of card or made by your thumb and fingers. To ensure your colour is accurately mixed, try holding the paint on the brush or palette knife up to the subject and see if the colours coincide. Always thoroughly mix the paint on the palette before applying it to the picture. Before loading a brush up with a new colour it must be well cleaned of the previous colour.

It is advisable to use as few colours as possible in a mixture to avoid muddying and possibly long-term unwanted chemical reactions between pigments. Sometimes, though, one does not hit on the right mixture until numerous adjustments with traces of other colours are made.

BELOW A selection of palette knives.

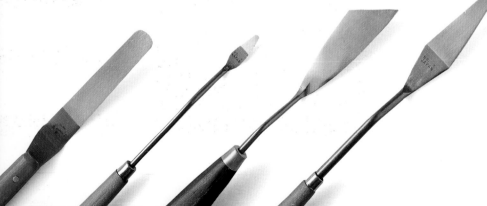

RIGHT Generally you should use a palette knife to mix your colours.

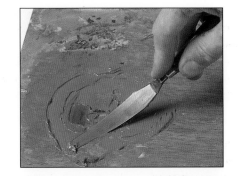

RIGHT Change the size of your palette knife according to the amount of paint you are mixing.

RIGHT Use brushes sparingly when mixing, since they tend to get worn easily.

THE STARTER PALETTE

As you will gather from the following pages a vast range of colours is obtainable from very few tube colours. A starter palette of ten basic ones including white is as follows:

• French ultramarine
• yellow ochre
• raw umber
• Payne's grey
• cadmium yellow
• lemon yellow
• alizarin crimson
• cadmium red
• Winsor violet
• titanium white

Four more which are also quite useful are phthalo blue, sap green, burnt umber and ivory black. As you read through this section you will see the uses of extra paints that you will probably like to collect as you need them. The section also includes a few exotic ones which you will seldom need but which may prove essential for certain subjects.

Before embarking on a painting, all the paints you are likely to use should be spread out along the outer edge of the palette. This is to avoid fumbling with them later when you are trying to concentrate on the painting. Also it means you cannot be discouraged from using any one colour simply because it's not there ready for use. The centre of the palette is for mixing, and we will be concentrating on this in the following pages.

USEFUL COLOURS

phthalo blue

sap green

burnt umber

ivory black

EXOTIC COLOURS

carmine

cadmium green

rose

cobalt violet

SUGGESTED STARTER PALETTE

French ultramarine

yellow ochre

cadmium red

Winsor violet

alizarin crimson

raw umber

titanium white

lemon yellow

Payne's grey

cadmium yellow

MIXING BLUE – SKY AND SEA COLOURS

Only rarely does an unmixed blue, straight from the tube, meet one's needs. Although the sky, the ocean or a blue lake may appear very blue they are in fact very muted and usually vastly different from any tube colour. On these pages are mixed a selection of "blues" typical of what one may find in natural situations.

Also shown here is how very small amounts of yellow ochre can modify a French ultramarine/white mixture. Many such mixtures frequently correspond to the colours seen in the sky. Try also mixing with French ultramarine traces of other colours such as alizarin crimson to obtain sky colours.

The effect of mixing French ultramarine with viridian or raw umber and in each case a trace of white is also shown. Many of these mixtures may be found for example in a "dark blue" ocean, in shadows, among foliage, or on the shaded walls of buildings.

** represents a 10:1 French ultramarine/white mixture
* represents a 1:1 French ultramarine/white mixture

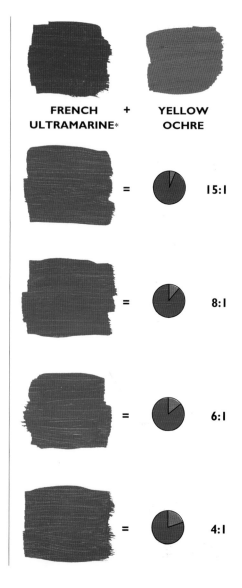

FRENCH ULTRAMARINE* + YELLOW OCHRE

= 15:1

= 8:1

= 6:1

= 4:1

FRENCH **+** **VIRIDIAN**
ULTRAMARINE

FRENCH **+** **RAW UMBER**
ULTRAMARINE∗∗

 = 3:1

 = 20:1

 = 2:1

 = 16:1

 = 1:1

 = 14:1

 = 1:2

 = 10:1

LIGHTENING AND DARKENING BLUE MIXTURES

French ultramarine with traces of cadmium yellow provides us with blues tending towards green, colours often used for distant landscape.

A blue can be made paler without losing its particular quality simply by adding white. Indeed a small amount of white intensifies the "blueness" of the darker tube colours such as French ultramarine blue, which explains why painters often use such mixtures as base colours. Darkening a blue is often achieved most effectively by mixing colours other than black, as shown here with a phthalo blue/cadmium red mixture.

* represents a 10:1 French ultramarine/white mixture

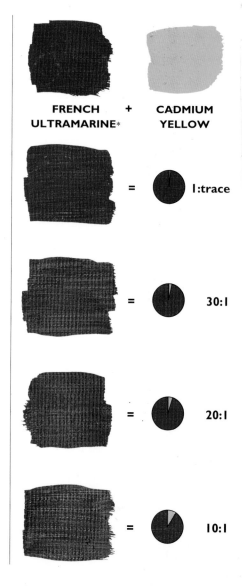

FRENCH ULTRAMARINE* + **CADMIUM YELLOW**

= 1:trace

= 30:1

= 20:1

= 10:1

CERULEAN **+** **WHITE** **PHTHALO** **+** **CADMIUM RED**
BLUE **BLUE**

 = 1:4 = 12:1

 = 1:2 = 8:1

 = 1:1 = 4:1

 = 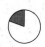 3:1 = 2:1

STILL LIFE – BLUE

This rather unlikely collection of blue objects provides an excellent exercise in choosing and mixing blue paints. Interestingly, the pigments used in colouring glass or earthenware are often the same as those used to make paints. For instance the glass jug to the right is identical to phthalo blue

2 cobalt blue
I French ultramarine
I ivory black

I cobalt blue
2 white

pure French ultramarine

I French ultramarine trace white

whereas the plate and the brandy glass are pure French ultramarine. Notice how the shapes of these forms stand out as some parts are lit and highlighted and others are plunged into shadow. The background is as important as the subject of a painting. Observe carefully how it varies.

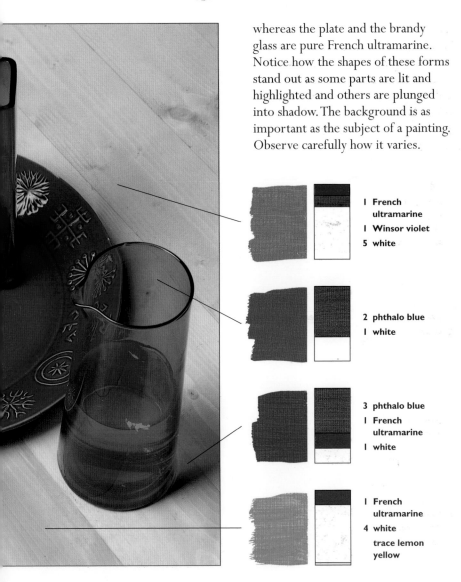

I **French ultramarine**
I **Winsor violet**
5 **white**

2 **phthalo blue**
I **white**

3 **phthalo blue**
I **French ultramarine**
I **white**

I **French ultramarine**
4 **white**
 trace lemon yellow

GALLERY – BLUE

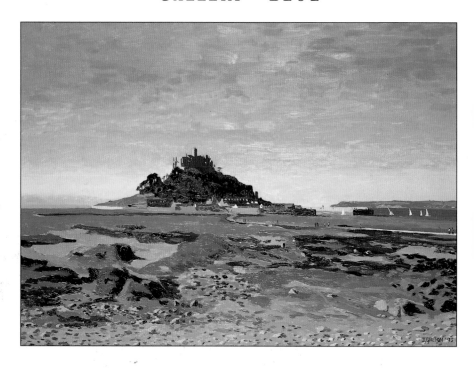

On this billiant autumn day the sky was an almost pure French
ultramarine / white mixture, particularly at the top right of the
picture. Increasingly towards the horizon the painter has mixed in
alizarin crimson, yellow ochre and raw umber. The water in the rock
pools reflects the same colours but toned down further still. The dark
blue shaded side of the castle is based on Payne's grey with additions
of French ultramarine and white. The distant hills contain a good
proportion of Winsor violet.

GALLERY – YELLOW

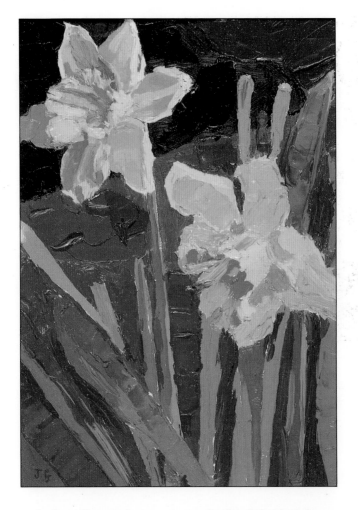

In this small picture the paints were mixed and applied with a palette knife. Notice how little cadmium yellow is used pure, the majority of the yellow being toned down or darkened with raw umber, French ultramarine and Winsor violet.

MIXING YELLOW

These pages show some ways in which the two most commonly used yellows, cadmium and lemon, can be lightened and darkened. Lightening can only be achieved by adding white. Notice just how much has to be added to cadmium yellow to have any effect. When it does, i.e., with large amounts of white, the yellow's brilliant character is lost. Lemon yellow on the other hand is better at keeping its "yellowness" on addition of white, and less white is in fact is needed. Both yellows are best darkened with browns or violets. Illustrated here are various mixtures of cadmium yellow with burnt umber, raw umber and Winsor violet, and a mixture of lemon yellow with yellow ochre.

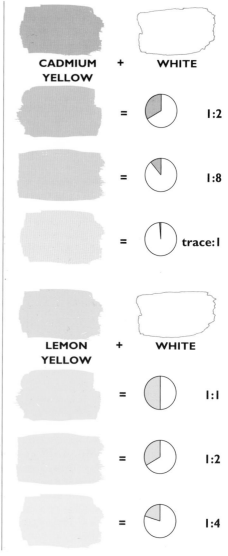

CADMIUM YELLOW + **WHITE**

= 1:2

= 1:8

= trace:1

LEMON YELLOW + **WHITE**

= 1:1

= 1:2

= 1:4

CADMIUM YELLOW	**+**	**BURNT UMBER**	

= 1:trace

= 8:1

= 3:1

CADMIUM YELLOW	**+**	**RAW UMBER**	

= 1:trace

= 8:1

= 3:1

LEMON YELLOW	**+**	**YELLOW OCHRE**	

= 1:trace

= 10:1

= 3:1

CADMIUM YELLOW	**+**	**WINSOR VIOLET**	

= 1:trace

= 8:1

= 4:1

STILL LIFE – YELLOW

Natural yellow objects are seldom as bright and pure in colour as they may seem. Although the most strongly lit areas of a lemon may appear almost pure lemon yellow the majority of the surface may well have to be described in browns or other colours depending on the reflections it

8 lemon yellow
1 yellow ochre

6 cadmium yellow
2 burnt umber
1 cadmium red

4 white
1 lemon yellow
1 yellow ochre

4 cadmium yellow
2 cadmium red
1 burnt umber

receives from its surroundings. The lemon pot at the top right of the photograph curves round into a dark red brown shadow and at its extreme right edge is lit with a bluish reflection from the board behind. Much of the enjoyment in painting a still life is in the discovery of the unexpected.

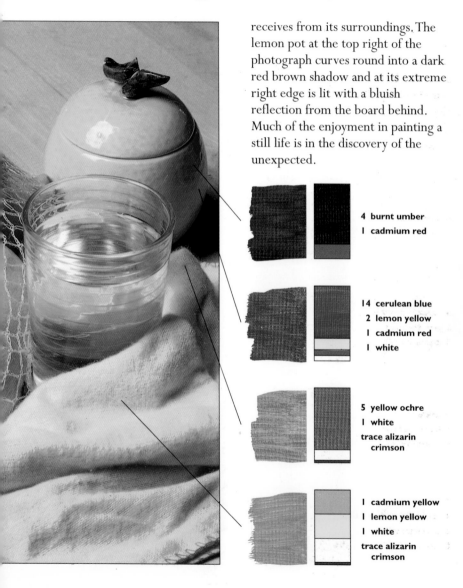

4 burnt umber
1 cadmium red

14 cerulean blue
2 lemon yellow
1 cadmium red
1 white

5 yellow ochre
1 white
trace alizarin
 crimson

1 cadmium yellow
1 lemon yellow
1 white
trace alizarin
 crimson

MIXING RED

It is not normally necessary to own more than two or three red tube colours. One orange-biased colour such as cadmium red and one violet-biased one such as alizarin crimson are quite enough for most purposes. Darkening and lightening these colours requires some skill if their characteristic hues are to be retained. Simply adding white to cadmium red gives a washed-out pink but with the extra addition of a little cadmium yellow you can obtain a good pale version of cadmium red. Similarly the addition of black quickly destroys its quality whereas if burnt sienna (a reddish brown) or alizarin crimson is added instead an acceptable darkened cadmium red is formed.

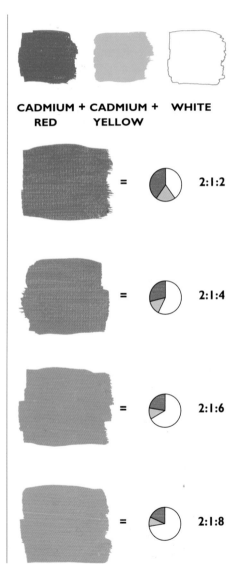

CADMIUM + CADMIUM + WHITE
RED YELLOW

= 2:1:2

= 2:1:4

= 2:1:6

= 2:1:8

CADMIUM RED + BURNT SIENNA

CADMIUM RED + ALIZARIN CRIMSON

 = 4:1

 = 2:1

 = 2:1

 = 1:1

 = 1:2

 = 1:2

 = 1:4

 = 1:3

MIXING PINK

The addition of varying amounts of white to our starter palette reds (alizarin crimson and cadmium red) will give a number of pinks. These can be modified by traces of other colours producing most of the hues commonly found in, for example, skin, fruit, brickwork, or even sunsets. However, when you are painting flowers you will often need colours of greater brilliance. On these pages are mixed a selection of the brightest reds and violets with, firstly, two parts and then four parts white. It is helpful to be familiar with the characteristic qualities of these colours to avoid wasting time in trial and error. After all, petals drop, buds open and flower heads turn to the light. Speed is essential!

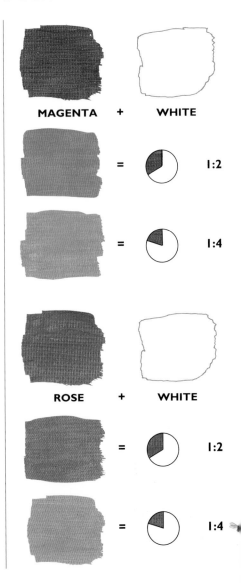

MAGENTA + WHITE

= 1:2

= 1:4

ROSE + WHITE

= 1:2

= 1:4

GERANIUM RED + **WHITE**

 = 1:2

= 1:4

CARMINE **+** **WHITE**

 = 1:2

 = 1:4

COBALT VIOLET **+** **WHITE**

 = 1:2

 = 1:4

VENETIAN RED **+** **WHITE**

 = 1:2

 = 1:4

STILL LIFE – RED

All these objects are similar in colour and the reflections each receives is mostly from other surrounding red objects. And yet the variety of hues found here is surprisingly wide. Perhaps the most difficult colours to mix are the very dark tones. For the jug's shadow cast on the red book you

2 **alizarin crimson**
2 **cadmium red**
1 **white**

1 **alizarin crimson**
1 **cadmium red**

1 **alizarin crimson**
1 **carmine**
2 **white**
**trace lemon
 yellow**

1 **alizarin crimson**
1 **carmine**

could use alizarin crimson darkened with cadmium green, approximately its complementary colour. For the accurate portrayal of many painted or glazed objects it is often necessary to use such exotic colours as carmine red, for example for the saucer in this photograph.

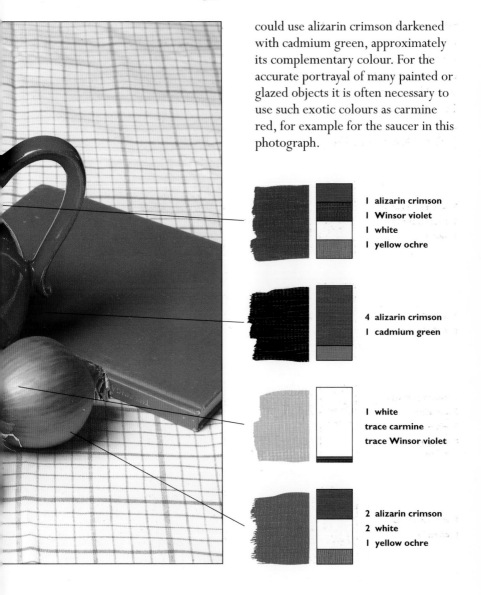

1 alizarin crimson
1 Winsor violet
1 white
1 yellow ochre

4 alizarin crimson
1 cadmium green

1 white
trace carmine
trace Winsor violet

2 alizarin crimson
2 white
1 yellow ochre

GALLERY – RED

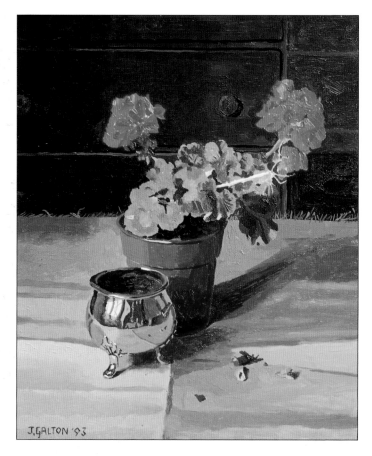

J.GALTON '93

Tackling brightly-coloured flowers often necessitates the use of
tube colours which you would not normally have on your palette.
Although pure cadmium red corresponds well to the colour of poppies,
for example, here the painter used cadmium scarlet and the brilliant
but fugitive geranium lake in addition. The latter colour will fade,
particularly if mixed with other colours. The flower pot is
painted in mixtures based on burnt sienna.

GALLERY – ORANGE

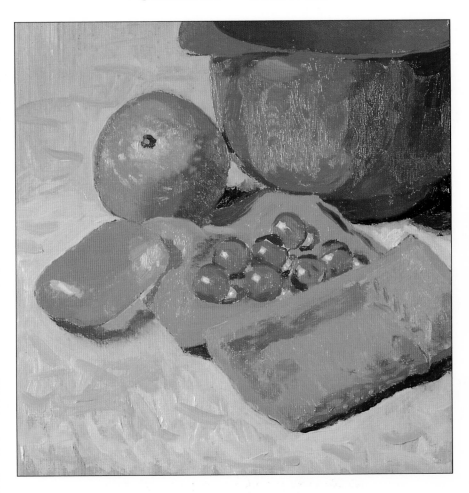

A still life exercise such as this provides an excellent opportunity to explore the relationships between objects of a similar colour. With so much orange to consider the painter was forced to look for all the small variations in hue and value in order to give form and depth to the subject.

MIXING ORANGE

The best orange colours are made by mixing cadmium red with cadmium yellow because both tend towards orange. They are the tube primaries adjacent to orange in the colour wheel. Such mixtures are identical to the orange tube colours and so it is not necessary to buy them. Alizarin crimson and lemon yellow do not produce a satisfactory orange so this combination is omitted here. However, as long as one component of the red-yellow pairs is a cadmium colour a mixture we can call "orange" will be produced.

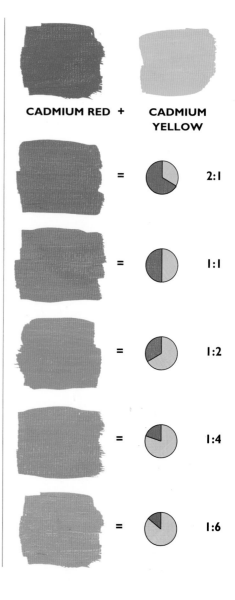

CADMIUM RED + **CADMIUM YELLOW**

= 2:1

= 1:1

= 1:2

= 1:4

= 1:6

ALIZARIN CRIMSON	**+**	**CADMIUM YELLOW**	**CADMIUM RED** **+**	**LEMON YELLOW**

 = 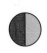 1:1 = 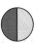 1:1

 = 1:2 = 1:2

 = 1:4 = 1:4

 = 1:6 = 1:6

 = 1:10 = 1:10

STILL LIFE – ORANGE

Most orange colours can be mixed simply with various reds and yellows in varying proportions, perhaps toned down with green or the complementary colour to orange, blue. Look carefully at an orange and see how its shaded side appears basically brown. The colour of this

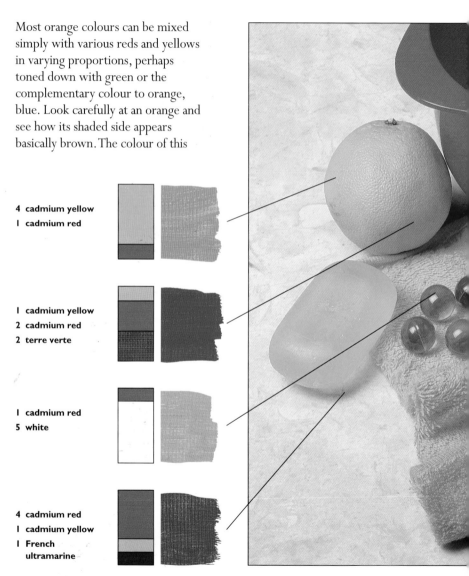

4 cadmium yellow
I cadmium red

I cadmium yellow
2 cadmium red
2 terre verte

I cadmium red
5 white

4 cadmium red
I cadmium yellow
I French
ultramarine

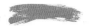

shadow will be modified by reflections
received by nearby objects, sometimes
creating the most unexpected colours.
The colours of reflected highlights on
shiny orange objects will depend
mostly on the illumination and to a
small extent on the exact colour
beneath the reflection.

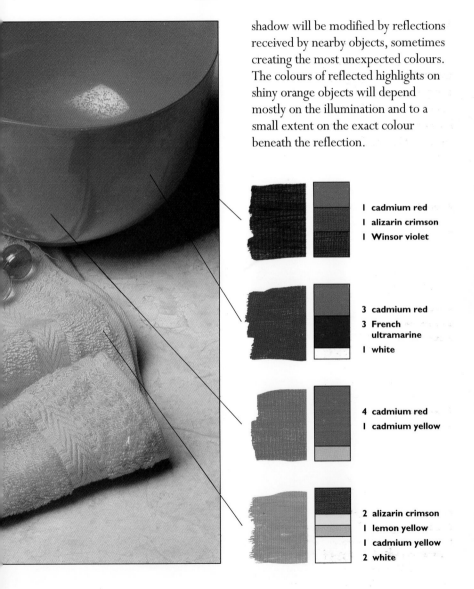

1 cadmium red
1 alizarin crimson
1 Winsor violet

3 cadmium red
3 French
ultramarine
1 white

4 cadmium red
1 cadmium yellow

2 alizarin crimson
1 lemon yellow
1 cadmium yellow
2 white

MIXING GREEN

From the many blues, blacks and yellows available, a staggering range of greens can be mixed. In general the greener the blue such as phthalo blue or cerulean blue for example, the greater their "greening" effect when mixed with yellow. Often only a trace of blue can change a yellow to a respectable green, while a trace of yellow has little effect on a blue. Notice the rich greens that can be made from Payne's grey, which actually has a large element of blue in it.

FRENCH ULTRAMARINE + **CADMIUM YELLOW**

1:20

1:10

1:2

1:1

2:1

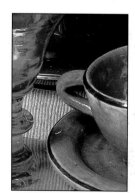

| PAYNE'S GREY | + | LEMON YELLOW | | CERULEAN BLUE | + | LEMON YELLOW |

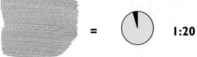 = 1:20 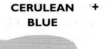 = 1:20

 = 1:10 = 1:10

= 1:4 = 1:1

= 1:2 = 2:1

 = 1:2 = 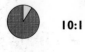 10:1

MIXING DARK GREEN

Phthalo blue is a powerful greenish blue and mixes with yellows to form brilliant greens that are unlikely to be found in nature. However, with yellow ochre (a dull yellow/pale brown) small quantities of phthalo blue can form some beautiful cool greens, very useful for foliage. Ivory black has only a hint of blue in it and when mixed with yellow forms a series of dull, although warm, colours that can just about be classed as "green."

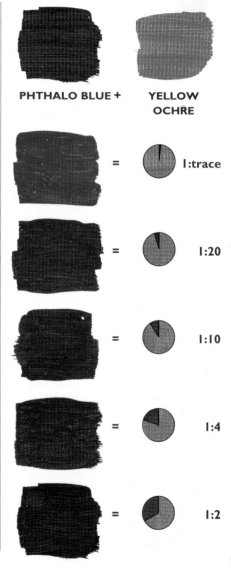

PHTHALO BLUE + **YELLOW OCHRE**

= 1:trace

= 1:20

= 1:10

= 1:4

= 1:2

| IVORY BLACK | + | CADMIUM YELLOW | | SAP GREEN | + | IVORY BLACK |

 = 1:6 = 6:1

 = 1:3 = 3:1

 = 1:2 = 1:1

 = 2:3 = 2:3

 = 1:1 = 1:3

USEFUL GREEN MIXTURES

Often when painting shaded foliage in a landscape or still life you will need the darkest greens. A simple way to achieve such tones is to add black to an already dark green – a popular one is sap green. Incidentally, when white is added to these mixtures a whole new range of lovely colours presents itself as shown on the previous page.

A strong, bright colour such as cadmium green would seldom be used "neat" in a painting but once it has been

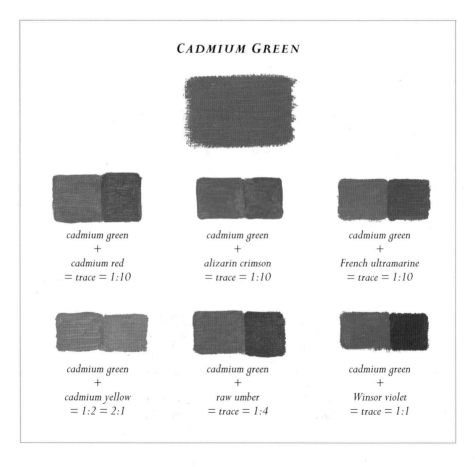

CADMIUM GREEN

cadmium green
+
cadmium red
= trace = 1:10

cadmium green
+
alizarin crimson
= trace = 1:10

cadmium green
+
French ultramarine
= trace = 1:10

cadmium green
+
cadmium yellow
= 1:2 = 2:1

cadmium green
+
raw umber
= trace = 1:4

cadmium green
+
Winsor violet
= trace = 1:1

modified or subdued by the addition of other colours, a useful range of greens are produced. In contrast terre verte is a rather transparent paint of low tinting strength. It can either be used to increase the bulk of a paint mixture without changing its colour much or it can be a useful foundation to which mere traces of other colours can be added in order to alter its appearance quite significantly.

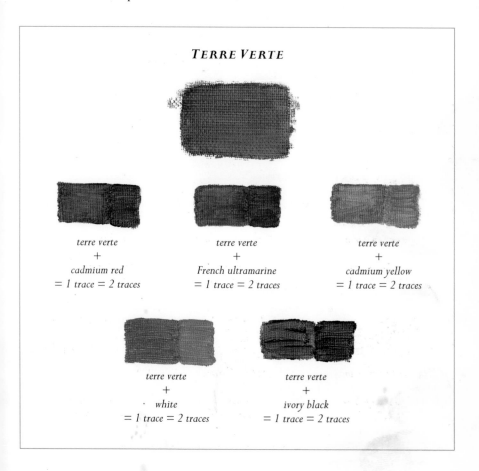

TERRE VERTE

terre verte
+
cadmium red
= 1 trace = 2 traces

terre verte
+
French ultramarine
= 1 trace = 2 traces

terre verte
+
cadmium yellow
= 1 trace = 2 traces

terre verte
+
white
= 1 trace = 2 traces

terre verte
+
ivory black
= 1 trace = 2 traces

STILL LIFE – GREEN

Green tube colours are used rarely
except to modify other colours or to
produce the darker values with sap
green. The shaded area of the cup in
this photograph is an example of the
latter. Notice how the painter has
used phthalo blue to produce the
cooler, bluer greens and French

3 **phthalo blue**
1 **cadmium yellow**
trace white

6 **phthalo blue**
1 **cadmium yellow**
2 **white**

2 **phthalo blue**
2 **Payne's grey**
1 **lemon yellow**
1 **white**
trace cadmium
 yellow
trace French
 ultramarine

3 **phthalo blue**
4 **yellow ochre**
4 **white**
1 **cadmium yellow**

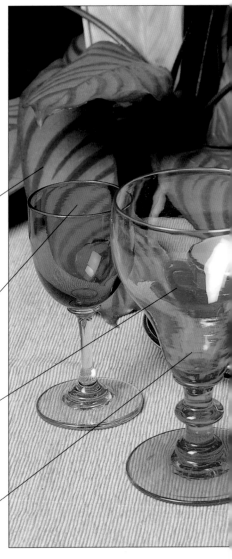

ultramarine to produce the warmer, yellower greens. Although as few colours as possible should be mixed, sometimes it is difficult to discover the right mixture straight away and you will find that numerous adjustments, using traces of other colours will have to be made.

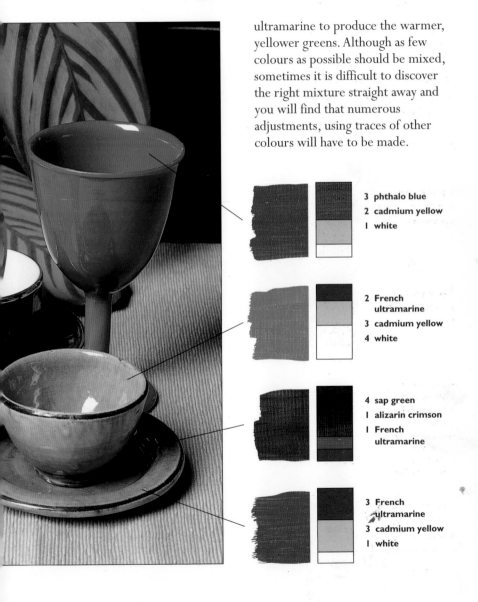

3 phthalo blue
2 cadmium yellow
1 white

2 French
 ultramarine
3 cadmium yellow
4 white

4 sap green
1 alizarin crimson
1 French
 ultramarine

3 French
 ultramarine
3 cadmium yellow
1 white

GALLERY – GREEN

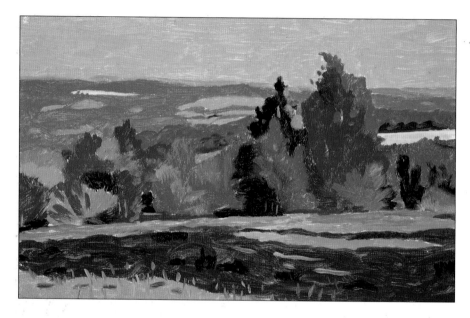

*This oil sketch was painted very quickly, the main row of trees
being blocked in with just a few greens. Payne's grey or French
ultramarine with cadmium yellow in varying proportions were
mostly used. The darkest shadows are mixtures based on sap
green with ivory black or Payne's grey.*

GALLERY – VIOLET

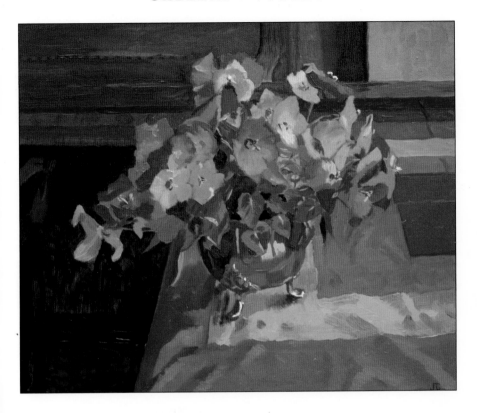

*A mixture of Winsor violet and white corresponded well to the
local colour of these petals. For the highlighted areas and the petals in
shadow the painter added alizarin crimson and/or French ultramarine
in varying proportions. It is important to look carefully at
the gradations in colour and tone so that the structure
of the petals can be defined.*

MIXING VIOLET

Violets are secondary colours made by mixing blues and reds. The more the chosen blue and red tend towards violet (their common neighbour in the colour wheel) the more intense the resulting violet. French ultramarine, alizarin crimson and rose red are examples. In contrast, phthalo blue which is green biased, produces only weak violets. French ultramarine when mixed with cadmium red, which tends towards orange rather than violet, results in colours normally described as browns and greys. Such mixtures are illustrated in the sections on browns and greys.

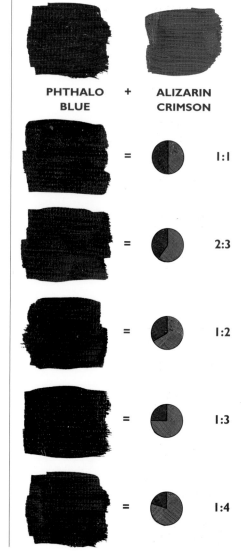

PHTHALO BLUE + **ALIZARIN CRIMSON**

= 1:1

= 2:3

= 1:2

= 1:3

= 1:4

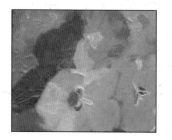

CERULEAN BLUE + **PERMANENT ROSE** **FRENCH ULTRAMARINE** + **ALIZARIN CRIMSON**

 = 8:1 = 4:1

 = 6:1 = 3:1

 = 3:1 = 2:1

 = 2:1 = 1:1

 = 1:1 = 2:3

STILL LIFE – VIOLET

Generally you will find that most violets can be mixed from the primary reds and blues. However, Winsor violet is recommended as part of your basic palette because it corresponds to colours found in many natural situations. A blue sky reflected in wet sand and the shaded side of a

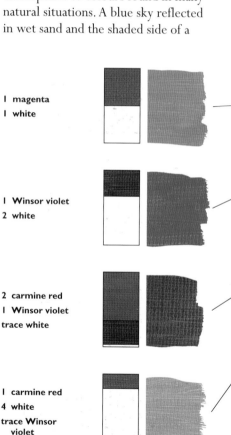

1 magenta
1 white

1 Winsor violet
2 white

2 carmine red
1 Winsor violet
trace white

1 carmine red
4 white
trace Winsor
violet

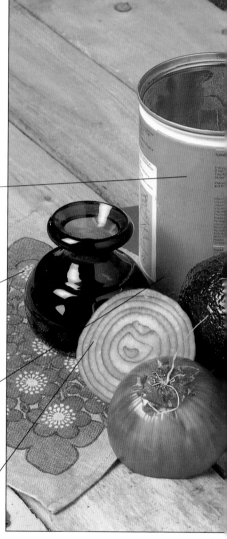

white building are examples. For the most brilliant of violets – those found in flowers or artificially coloured objects such as in this still life photograph – you will probably have to resort to using magenta, carmine or rose as shown here.

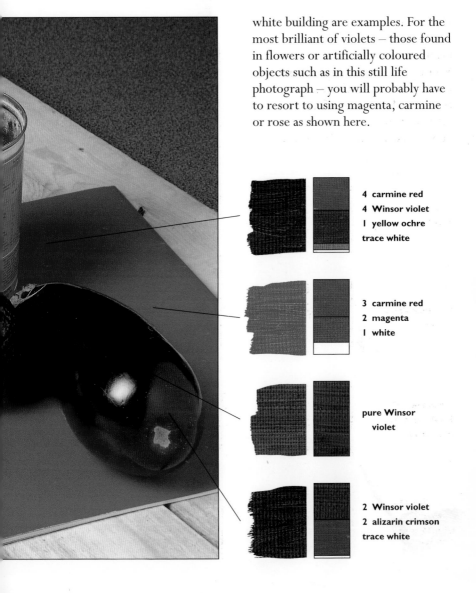

4 carmine red
4 Winsor violet
1 yellow ochre
trace white

3 carmine red
2 magenta
1 white

pure Winsor violet

2 Winsor violet
2 alizarin crimson
trace white

MIXING BROWN USING COMPLEMENTARY COLOURS

A wonderful range of rich browns can be obtained by mixing pairs of complementary colours together. Such a complementary pair will always consist of one primary and one secondary colour. Brown is essentially a dark yellow. An excellent way to darken, say, cadmium yellow is to add its complementary colour, Winsor violet. As long as the colours to be mixed are warm, with a hint of yellow in them, then a brown rather than a grey results. For example, cadmium red and cadmium green are both warm colours. Notice how much cooler the browns are when cadmium red is mixed with viridian instead.

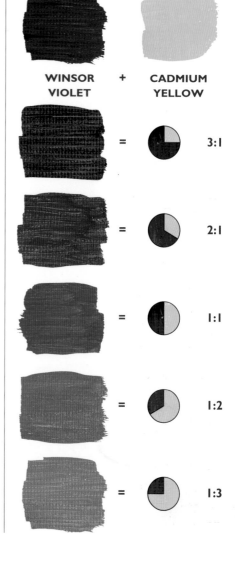

WINSOR VIOLET + **CADMIUM YELLOW**

= 3:1

= 2:1

= 1:1

= 1:2

= 1:3

CADMIUM RED + CADMIUM GREEN **CADMIUM RED + VIRIDIAN**

 = 1:1 = 1:1

 = 1:2 = 1:2

 = 1:3 = 1:4

 = 1:4 = 1:6

 = 1:5 = 1:9

MIXING BROWN USING PRIMARY COLOURS

Mixtures of some pairs of primary colours give acceptable browns or greys. This occurs when they do not form good secondary colours. For instance, one may expect French ultramarine and cadmium red to form violet, but in reality the resulting muddy colours can provide useful browns. With higher blue ratios the browns tend towards grey as can be seen in the section on greys.

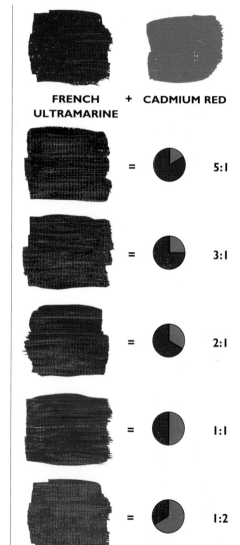

FRENCH ULTRAMARINE + **CADMIUM RED**

= 5:1

= 3:1

= 2:1

= 1:1

= 1:2

FRENCH ULTRAMARINE	+	**YELLOW OCHRE**		**LEMON YELLOW**	+ **ALIZARIN CRIMSON**

 = **1:2** = **1:trace**

 = **1:3** = **20:1**

 = **1:5** = **12:1**

 = **1:9** = **9:1**

 = **1:19** = **4:1**

STILL LIFE – BROWN

The browns in this still life are surprisingly colourful. One of the excitements of painting is in the discovery of colours that you would not normally have noticed. Most of the browns for this picture have been obtained by mixing primary colours. Of course, instead, you could arrive

3 **cadmium yellow**
1 **alizarin crimson**
1 **cobalt blue**
3 **white**
trace cadmium red

1 **yellow ochre**
2 **white**

4 **cerulean blue**
3 **alizarin crimson**
4 **cadmium yellow**

2 **burnt umber**
1 **cadmium red**

at these same hues by modifying ready made browns. The danger here is that a monotonous sameness can pervade the colours leading to a dull painting. However, for the very darkest browns it is often advisable to begin with a dark earth colour such as burnt umber.

4 burnt umber
1 French ultramarine
1 ivory black

2 alizarin crimson
1 cadmium yellow
1 cobalt blue
2 white

1 white
trace alizarin crimson
trace Winsor violet

2 cadmium yellow
1 cadmium red
1 cobalt blue
2 white

GALLERY – BROWN

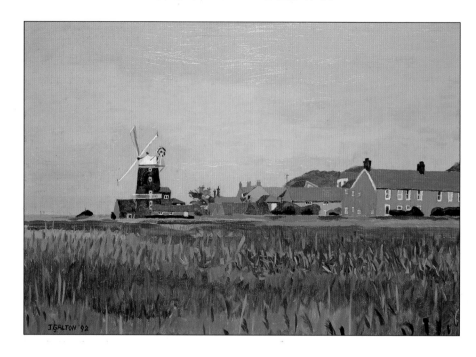

The base of the mill is pure burnt umber as are the darkest of the flowering reed heads. The broad, brown areas of the reed bed are painted in a thinned raw umber/yellow ochre in the manner of the watercolourist's wash. Some individual reeds are painted over this. The warm browns of the roof top are mixtures of cadmium red, French ultramarine and cadmium yellow modified with minute additions of other colours.

GALLERY – GREY

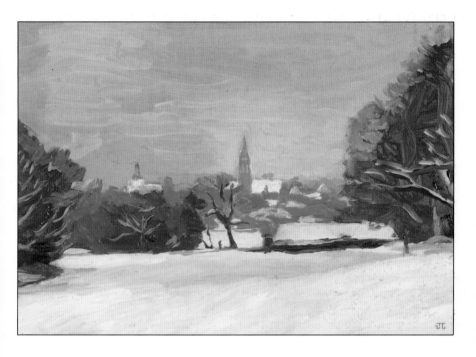

The greys of the sky, the distant houses and the snow are all mixtures
of French ultramarine with various reds, yellows and violet. Note that
no black or tube grey has been used in this painting. Each colour has
been mixed until it exactly matches the colour of the subject. This is
checked by holding up the loaded brush so that the colour of the paint
can be compared side by side with the colour of the subject.

MIXING GREY

Grey is a very vague term describing an infinite range of highly muted and impure colours. Even the most neutral of greys obtained by mixing white with lamp black will take on a coloured appearance in juxtaposition with other colours. All the greys illustrated here appear quite coloured, but in isolation or in the right context can appear just "grey." They tend to result when a cool pair of complementary colours is mixed or when three cool primaries are mixed. An apparent exception is French ultramarine with cadmium red – the latter has a strong hint of orange in it, the complementary colour of blue. All the greys on this page are shown both as single colour mixtures as well as with some added white.

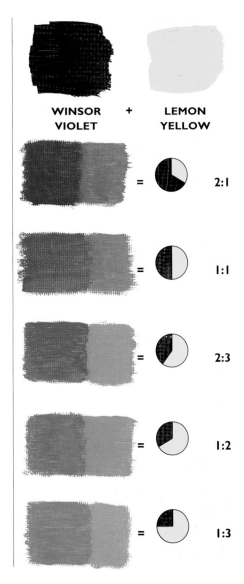

WINSOR VIOLET + **LEMON YELLOW**

2:1

1:1

2:3

1:2

1:3

FRENCH ULTRAMARINE +	**CADMIUM RED**	**VIRIDIAN** + **ALIZARIN CRIMSON**

 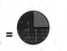 = 3:1 = 7:1

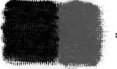 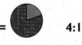 = 4:1 = 9:1

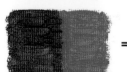 = 5:1 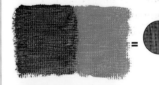 = 12:1

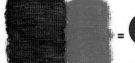 = 6:1 = 16:1

 = 8:1 = 20:1

STILL LIFE – GREY

Unpolished or matte-finished metal such as the stainless steel cup in this photograph often appears as an assortment of greys owing to light-scattering at its surface. In contrast the appearance of the glass is made up of the distorted shapes and grey colours of the pebbles that we see through it. Notice how all of the

7 viridian
1 alizarin crimson
2 white

2 French
 ultramarine
1 alizarin crimson
2 lemon yellow
trace white

3 French
 ultramarine
1 alizarin crimson
trace lemon
 yellow

3 viridian
1 alizarin crimson
6 white

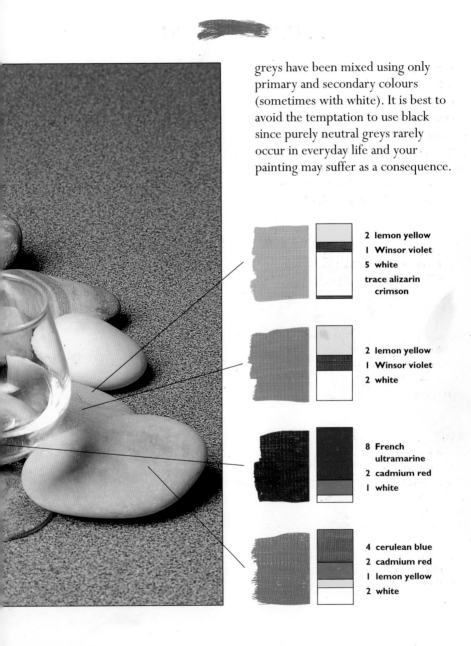

greys have been mixed using only primary and secondary colours (sometimes with white). It is best to avoid the temptation to use black since purely neutral greys rarely occur in everyday life and your painting may suffer as a consequence.

2 **lemon yellow**
I **Winsor violet**
5 **white**
trace **alizarin crimson**

2 **lemon yellow**
I **Winsor violet**
2 **white**

8 **French ultramarine**
2 **cadmium red**
I **white**

4 **cerulean blue**
2 **cadmium red**
I **lemon yellow**
2 **white**

WATERCOLOURS

Watercolours mix in a way that is special to them, not always in the way that colour theory or even common sense might suggest. Many artists who are new to the medium are unprepared for this and are disappointed with the colour mixing in their own paintings. Such people may find this section helpful, as may others who have had more experience in watercolour painting.

The dilution of colours plays an important part in watercolour mixing. The colour palettes featured in this section have been mixed from tubes of artist's quality watercolour diluted with water to provide an even, fluid consistency – a "standard mixture" or dilution. Some colours require more dilution than others to give the same coverage, and if you want to experiment, you should make a series of trial patches to determine the amount of water required in a mixture.

Combinations of colours are created from standard solutions of two colours. The new colours can then be used in weak, standard or strong dilutions as required. A weak dilution, or mixture, is one using more water than a standard dilution, while a strong dilution uses less water, creating a more opaque effect.

Weak dilution or mix (more water)

In the case of watercolours you will discover that some colours readily combine with others to produce good, even washes, while other colours seem reluctant to mix evenly and will even tend to separate when laid down. Although it could be argued that such colours should be avoided, mixtures using them can give watercolour that very quality that is so special to the medium.

Standard dilution

Strong dilution (less wtaer)

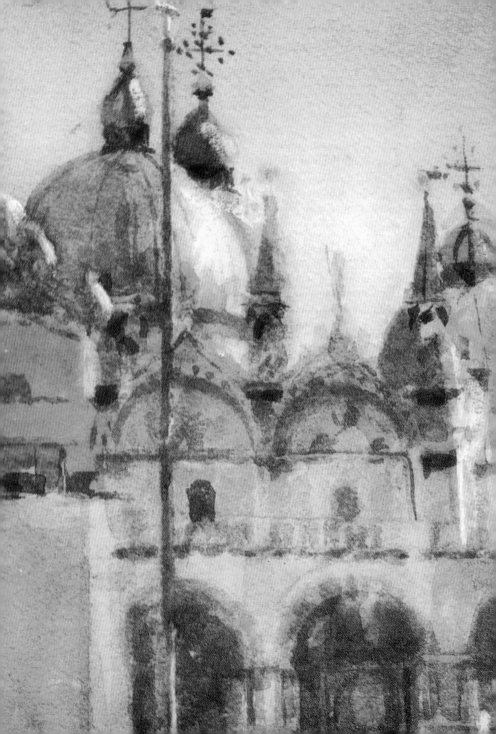

THE USE OF WATER IN MIXING COLOUR

When you are painting, the colours you mix will, of course, be determined by the pigments you use, but another important ingredient in the mixture is water. The range of any colour can be extended from its darkest tone right through to the lightest of tints simply by adding water.

When it is applied to paper a weak mixture with plenty of water will allow the whiteness of the paper to show through. Even fairly strong mixtures of watercolour will never be entirely opaque, but it is possible to produce strong colours in your paintings by building them up so that two, three or even more colours are laid on top of one another. Remember to allow each layer to dry before applying the next. Always avoid using colour in a concentrated form with only the smallest amount of water. If you do, your painting will not look like a watercolour and your pigments could develop an unpleasant shiny surface.

TRANSLUCENT COLOURS

Much of the beauty of watercolour comes from the delicacy of overlaid watery washes. It is this quality of translucency that allows colours to be created on the paper rather than on the palette. For example, paint a small area of light blue watercolour, allow it to dry, and then paint over the top with a yellow. Where the two colours overlap a delicate green will result.

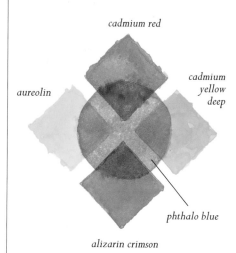

cadmium red

cadmium yellow deep

aureolin

phthalo blue

alizarin crimson

See how overlaid colours change their hue.

Some painters exploit this characteristic of watercolour to produce works of great beauty, with the quality rather like stained glass. If you want to paint in this way it is important that your colour mixtures are made with generous amounts of water.

GRANULATION

It is possible to acheive beautiful and extremely even washes with watercolour, but it sometimes happens that a pigment will precipitate, or separate, especially when the wash contains plenty of water. The resulting effect is an uneven speckled texture, which can be quite interesting. Colours that are likely to do this are cerulean, French ultramarine, burnt umber, vermilion, raw umber and yellow ochre.

Backruns like these can be a blessing or a curse. In many cases such marks can give watercolours a free, loose quality that is unmatched by any other medium.

This broken surface of a wash is typical of granulation. Some colours will react in this way when they are mixed with large amounts of water.

WATER INTO PAINT

Watercolour can produce perfectly even and flat areas of pure colour that have a special kind of beauty, but wonderful effects are possible, too, when clean water is added to a wet painted surface. Doing this breaks up the watercolour and creates a range of graded colour effects. The results are always unpredictable, but it is this quality that can give the watercolour medium its special magic.

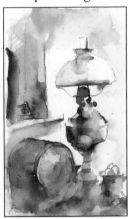

Unintentional effects of water often create wonderful images.

MIXING YELLOW

WARM AND COOL

Yellow is one of the lightest colours in your palette, and it can be the easiest to change. Often, just a small amount of blue can change it to green, and it is usually easy to alter yellow to orange by adding the tiniest amount of red.

Many subtle variations of yellow can be achieved by either mixing two yellows together or by mixing a yellow with an analogous or complementary colour. Because yellows are usually so delicate, however, great care must be taken when adding other colours so that the yellow hue is not lost altogether. Often, adding more than 10 percent of another colour is sufficient to alter a yellow so it loses its yellowness.

Greenish-yellows may be said to be cool, while orange yellows may be described as warm. The mixtures here demonstrate this.

The amounts of colour to be mixed together are indicated in brushfuls, or parts, of paint.

CADMIUM YELLOW + **INDIAN YELLOW**

= 10:1

= 10:2

= 10:3

= 10:5

= 10:7

 +

LEMON YELLOW + **PAYNE'S GREY**

GAMBOGE + **COBALT BLUE**

 = 40:1

 = 20:2

 = 40:2

 = 20:3

 = 40:3

 = 20:4

 = 40:4

 = 20:5

 = 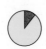 40:5

 = 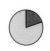 20:5

STILL LIFE – YELLOW

The yellows in this still life create some surprises. Some of them are both tonally darker and more orange than might be expected. Indeed, the melon and lemon might be described as "brownish."

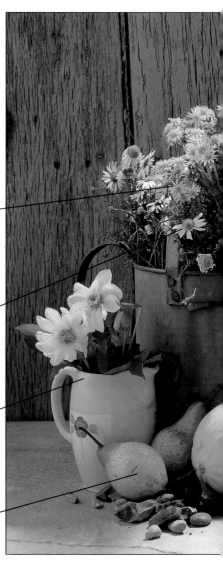

13 cadmum lemon
4 cadmium yellow deep
1 French ultramarine
2 cadmium red
standard dilution

17 gamboge
3 phthalo blue
weak dilution

11 lemon yellow
2 cadmium orange
3 burnt umber
4 Naples yellow
standard dilution

12 aureolin
3 indigo
4 vermilion
1 cadmium yellow deep
standard dilution

Altering the proportion of colours in a yellow mix will change its hue, but increasing or decreasing the amount of water used will have an effect on the depth of tone of the colour.

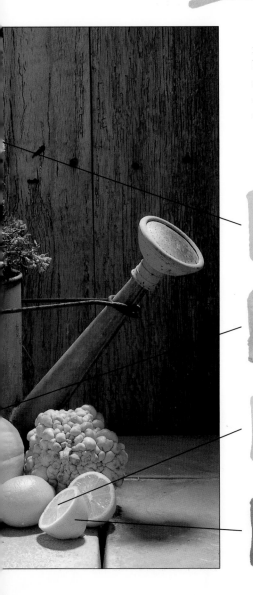

13 cadmium lemon
7 vermilion
weak dilution

12 lemon yellow
6 burnt umber
2 cadmium red
very weak dilution

14 aureolin
2 indigo
1 Payne's grey
3 vermilion
very weak dilution

10 lemon yellow
6 burnt umber
3 cadmium red
1 French ultramarine
standard dilution

MIXING ORANGE

There is no cool version of orange. A cool orange would in fact look more like brown. A true orange would be either a red orange or a yellow orange.

RED/ORANGE

Red orange colours can be mixed from both warm and cool reds and a wide range of yellows, but the strongest and most intense orange is mixed from a warm red and yellow – for example, vermilion and cadmium yellow. Red is the dominant partner in the mixture, and it is, therefore, usually better to add red to yellow. Adding extra red will, of course, produce a redder orange.

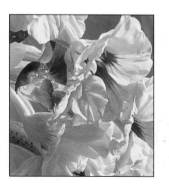

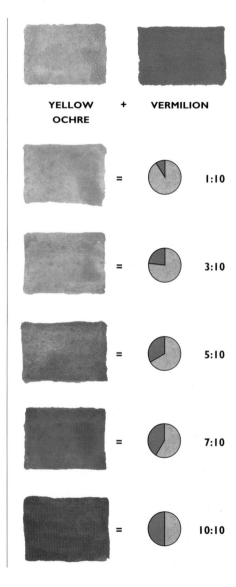

YELLOW OCHRE **+** **VERMILION**

= 1:10

= 3:10

= 5:10

= 7:10

= 10:10

INDIAN YELLOW	+	**WINSOR RED**	

	=	1:10
	=	2:10
	=	3:10
	=	4:10
	=	5:10

LEMON YELLOW	+	**ALIZARIN CRIMSON**	

	=	1:10
	=	2:10
	=	3:10
	=	4:10
	=	5:10

MIXING ORANGE

YELLOW ORANGE

It is possible to purchase proprietary yellow orange colours – cadmium orange, for example – but because this colour is so easy to mix, many watercolourists leave it out of their palettes. The most intense yellow orange is mixed with a warm yellow such as cadmium yellow deep and the smallest amount of a warm red. Make sure that you use a clean brush and that the mixing surface is clean, otherwise this colour will become easily degraded and lose its intensity.

A softer yellow orange may be mixed using a cool yellow, such as lemon yellow, as a base.

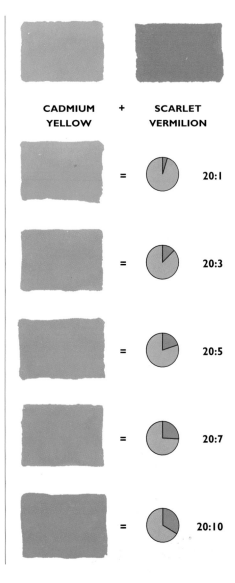

CADMIUM YELLOW + **SCARLET VERMILION**

= 20:1

= 20:3

= 20:5

= 20:7

= 20:10

AUREOLIN	**+**	**CARMINE**	

LEMON YELLOW	**+**	**WINSOR RED**	

 = **20:1**

 = **20:1**

 = **20:2**

 = **20:2**

 = **20:3**

 = **20:3**

 = **20:4**

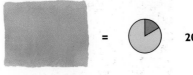 = **20:4**

 = **20:5**

 = 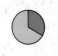 **20:10**

STILL LIFE – ORANGE

The various orange colours in this photograph are slightly duller and darker than may be expected.

To test this, take a piece of white paper and cut a square out of it measuring about 5 × 5mm (¼ × ¼ in). Lay the paper on the photograph with the hole over the

18 yellow ochre
 2 cadmium red
trace of Payne's grey
weak dilution

14 cadmium yellow
 deep
 6 cadmium red
weak dilution

14 cadmium orange
 deep
 5 burnt umber
 1 cadmium yellow
 deep
standard dilution

12 carmine
 8 cadmium yellow
 deep
standard dilution

shaded area of one of the oranges in the basket. You will see that the colour is more brown than orange.

Producing a painting from this subject involves making slight adjustments to the orange values so that the colours work successfully together.

14 cadmium lemon
 6 vermilion
standard dilution

10 cadmium lemon
 9 vermilion
 1 burnt umber
standard dilution

13 cadmium orange
 5 cadmium yellow
 deep
 1 burnt umber
 1 French
 ultramarine
weak dilution

11 cadmium red
 5 French
 ultramarine
 4 cadmium yellow
 deep
strong dilution

GALLERY – YELLOW AND ORANGE

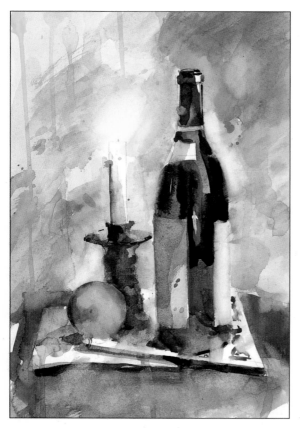

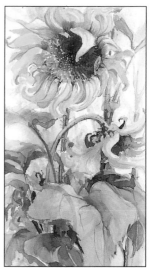

BELOW The sunflowers in this painting by Elizabeth Harden are warm yellow, almost orange. Most of the leaves are yellow with a hint of green, which means that the colour of the leaves and flowers work together. Notice how the colours have been kept under very tight control: Yellow can be very intense but the artist has very slightly neutralized the colours to avoid a glaring effect.

ABOVE The background for this painting was made up from a variety of yellows: yellow ochre, cadmium yellow, lemon yellow and aureolin. The colours were mixed on the paper together with amounts of cadmium red and French ultramarine. The effect is chaotic, but interesting painterly effects can be achieved by working this way. (John Lidzey)

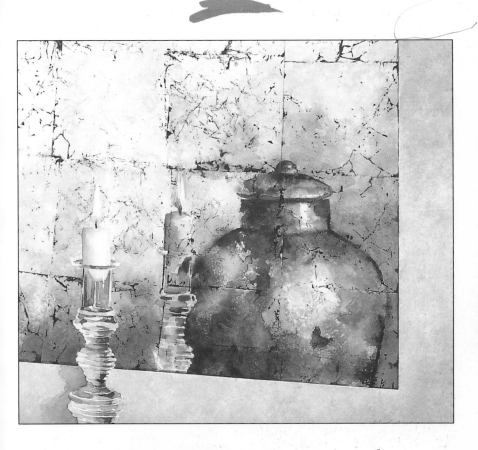

ABOVE This mysterious picture by Crin Gale makes very clever use of
intense red oranges and yellow oranges set against hues of a much
lower intensity. Gamboge, raw sienna and burnt umber have provided
the base for the orange parts of the copper vase and water has been
carefully used to vary the tonal values over the surface area.

MIXING RED

Many reds in tubes and pans are available to the watercolourist, but it is surprising how seldom one of these proprietary reds on its own will be suitable in a painting. Almost invariably the value will need to be altered, and often too, its intensity will need to be reduced. This can be achieved by adding a very small amount of its complementary colour, green.

WARM REDS

A warm red will incline towards an orange. Therefore, adding yellow to a red will nearly always cause it to become warmer. Even adding yellow to a cool red such as alizarin crimson will generate a warmer colour, although it will lose intensity.

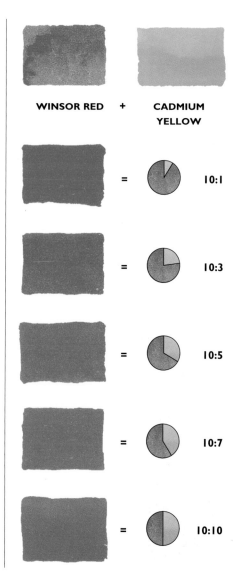

WINSOR RED + **CADMIUM YELLOW**

= 10:1

= 10:3

= 10:5

= 10:7

= 10:10

VERMILION + CRIMSON LAKE **CADMIUM RED + COBALT GREEN**

 = **10:1** = **10:1**

 = **10:2** = **10:3**

 = **10:3** = **10:5**

 = **10:4** = **10:7**

 = **10:5** = **10:10**

MIXING RED

COOL REDS

Carmine is an example of a proprietary cool red, alizarin crimson and rose madder are others. It is seldom possible to mix blues with warm reds to produce a cooler hue. Adding cerulean blue to permanent red, for example, will produce a cooler red, but it will lose its intensity and will become somewhat dirty. Many other mixtures of warm reds and blues will produce near browns or other degraded colours.

Mixing blues to cool reds will ususally cause them to become cooler without any loss of intensity. Carmine and ultramarine, for example, will work well together. Notice the strength of scarlet lake and the relative weakness of alizarin crimson.

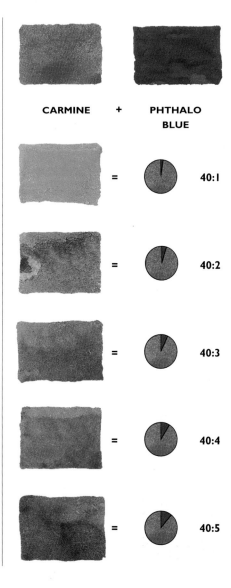

CARMINE + **PHTHALO BLUE**

= 40:1

= 40:2

= 40:3

= 40:4

= 40:5

SCARLET LAKE + CERULEAN BLUE **SCARLET LAKE + ALIZARIN CRIMSON**

 = 10:1 = 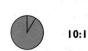 10:1

 = 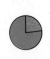 10:3 = 10:3

 = 10:7 = 10:7

 = 10:10 = 10:10

 = 10:15 = 10:15

STILL LIFE – RED

At first sight the range of reds in this
arrangement seems rather narrow,
but on closer inspection it can be seen
that it extends from the violet red on
the bottle cap to orange red on parts
of the basket. Some of the reds are
identical – the eggs in the basket and
the beads on the book, for example.

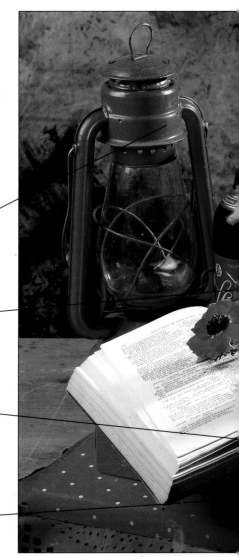

18 scarlet lake
 1 phthalo blue
 1 Payne's grey
standard dilution

10 purple madder
10 cadmium red
strong dilution

16 alizarin crimson
 2 vermilion
 2 phthalo blue
standard dilution

18 Winsor red
 2 French
 ultramarine

When you are choosing a colour to paint them, try using a mix of alizarin crimson and cadmium red.

The dark areas between the eggs and the shadows under the book could be painted with a strong red black, but the glass part of the bottle needs a cooler bluish-black.

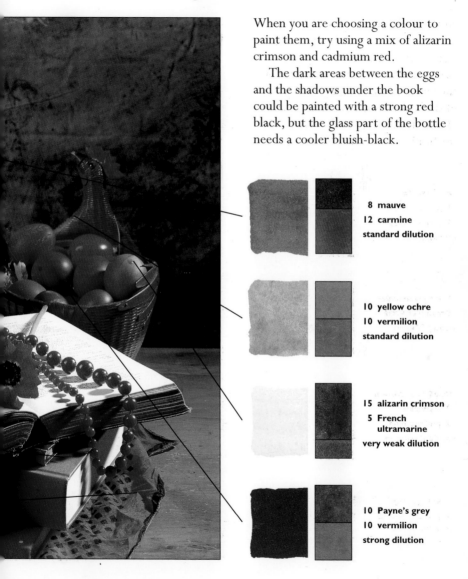

8 mauve
12 carmine
standard dilution

10 yellow ochre
10 vermilion
standard dilution

15 alizarin crimson
5 French
ultramarine
very weak dilution

10 Payne's grey
10 vermilion
strong dilution

GALLERY – RED

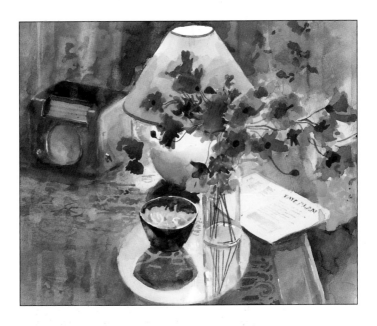

ABOVE *It is possible to mix very low intensity degraded reds and combine them with brighter and purer colours. These imitation poppies were painted in mixtures of carmine and indigo with the addition of Payne's grey for the very dark centres. The table was painted with a mixture of carmine, ultramarine, yellow ochre and Payne's grey. (John Lidzey)*

RIGHT *You can see how most of the reds in this painting by Elizabeth Harden are tending towards orange. Vermilion and cadmium red are examples of warm, orangish reds. It might be tempting to use such reds straight from the tube without any mixing, but in most cases this will produce an over-bright dazzling effect. Consider slightly neutralizing your reds with a complementary colour, or use water to reduce their strength.*

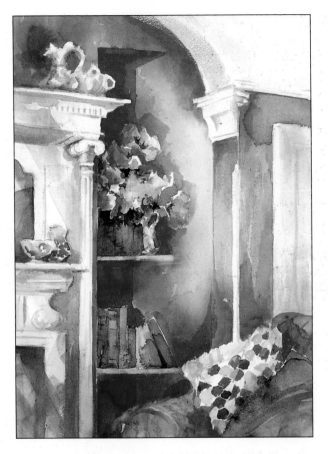

ABOVE This painting by Elizabeth Harden shows the use of
beautiful cool violet reds. These are combined with the
delicate violet colours on the mantelpiece, while the overlaying
of colours wet-on-dry has produced a variety of colour and tonal
effects. The addition of blue or violet to the mix has subtly
changed the red wall to a deep violet under the bottom shelf.

MIXING VIOLET

Blue combined with red produces violet. When a bright, intense violet is required it is better to select one from the proprietary range. Mixtures of reds and blues can lack their intensity.

WARM VIOLETS

The more blue that is added to the red, the cooler the violet becomes. Thus carmine with only a small amount of ultramarine produces a warm violet, which becomes progressively cooler as more blue is added. Cool proprietary violets can be warmed by adding red – for example, mauve can be considerably warmed by adding alizarin crimson.

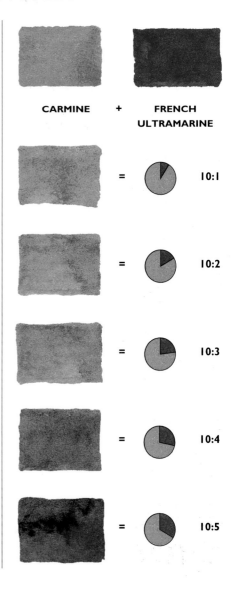

CARMINE + **FRENCH ULTRAMARINE**

= 10:1

= 10:2

= 10:3

= 10:4

= 10:5

ALIZARIN CRIMSON	**+**	**PURPLE MADDER**	

WINSOR RED	**+**	**PHTHALO BLUE**	

 = 10:1

 = 10:1

 = 10:3

 = 10:3

 = 10:5

 = 10:5

 = 10:7

 = 10:7

 = 10:10

 = 10:10

MIXING VIOLET

COOL VIOLETS

The best cool violets are mixed with cool reds. Phthalo blue and alizarin crimson can make a range of cool violets, as indeed can phthalo blue and carmine, although the amount of colours you use must be carefully controlled. The use of a Prussian blue in mixing violets is not normally recommended because its pigment can separate, producing a somewhat gritty result, especially in low grade watercolours. Low-toned violets can be produced by building up mixtures, allowing each layer to dry between applications.

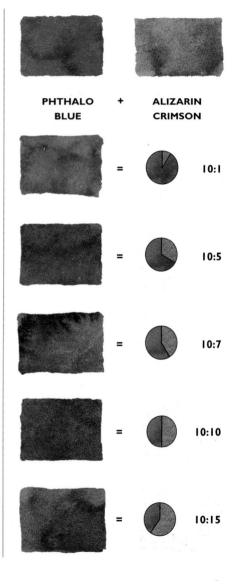

PHTHALO BLUE + **ALIZARIN CRIMSON**

= 10:1

= 10:5

= 10:7

= 10:10

= 10:15

MANGANESE + MAUVE
BLUE

INDIGO + CARMINE

 = 10:1 = 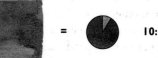 10:1

 = 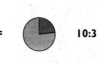 10:3 = 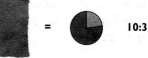 10:3

 = 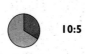 10:5 = 10:5

 = 10:7 = 10:7

 = 10:10 = 10:10

GALLERY – VIOLET

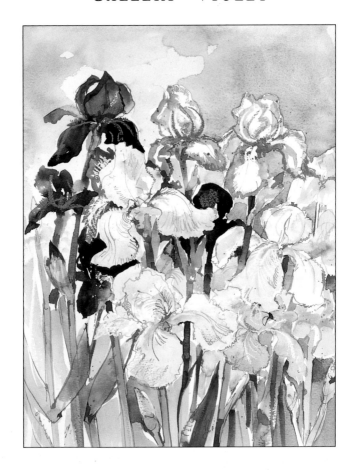

ABOVE Rather unusually, in producing this painting, Kay Ohsten
has used the same colour mauve from two different artists' paint
manufacturers. The difference between the two hues is quite
distinct so that they are both a feature of her paintbox. But to
achieve variety of hue and value, Payne's grey and small amounts
of alizarin crimson were used in the mixture.

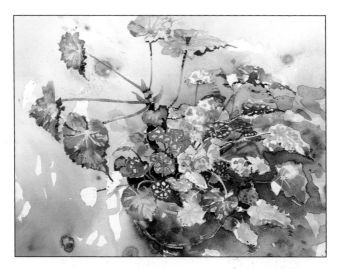

ABOVE Begonia leaves can show interesting violet hues together with softer, more earthy colours. In this loosely painted sketch by Kay Ohsten the background was brushed in mainly with magenta, mauve and indigo while the violet and red violet leaves were painted using mixtures from magenta, mauve, alizarin crimson, permanent blue and French ultramarine.

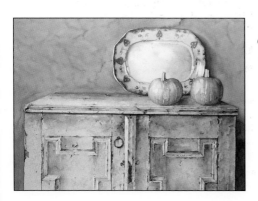

LEFT This beautiful and simple painting by Crin Gale sets a pale violet cupboard against a neutralized, complementary background. The colours used for the cupboard were French ultramarine, Indian red and rose madder. The background was created from burnt umber and cobalt blue. The tonal values on the cupboard were achieved by carefully controlling the paint density and by building up the colours wet-on-dry.

MIXING BLUE

There are many kinds of blues available to the watercolourist. Some blues – phthalo blue and Prussian blue, for example – are quite strong, but others – cerulean blue and cobalt blue, for instance – are relatively weak.

WARM BLUES

Although blue is regarded as a cool colour it can be seen that some blues are warmer than others. A warm blue tends towards the colour violet, while a cool blue tends to be slightly more greenish. Some proprietary blues can be warmed by adding a bluish red to the mixtures. For example, the smallest amount of alizarin crimson added to French ultramarine will provide a warmer blue. Other blues will become dirty, especially when they are mixed with a warm red.

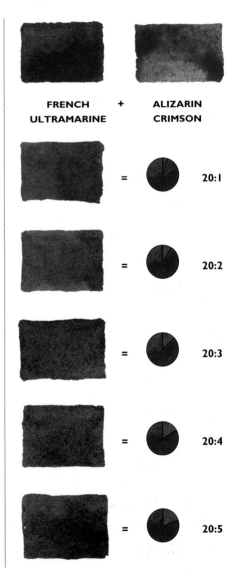

FRENCH ULTRAMARINE + **ALIZARIN CRIMSON**

= 20:1

= 20:2

= 20:3

= 20:4

= 20:5

			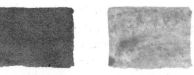	

COBALT BLUE + VERMILION **PERMANENT BLUE + DAVY'S GREY**

 = 10:1 = 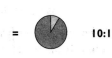 10:1

 = 10:2 = 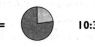 10:3

 = 10:3 = 10:5

 = 10:4 = 10:10

 = 10:5 = 10:20

MIXING BLUE

COOL BLUES

Cool blues can be seen as being somewhat greenish or turquoise in hue, but slightly degraded blues might also be seen as cool. A mixture of cobalt blue and raw umber will produce a quiet, cool blue, as will cerulean and vermilion. Adding the slightest amount of lemon yellow to French ultramarine will produce a useful cool blue.

The blues in your kit will not always provide the exact blue you need to match the blue in your subject, and you will often find that mixing two blues together will provide the colour you need.

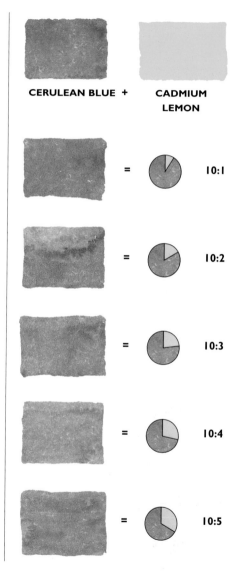

CERULEAN BLUE + CADMIUM LEMON

= 10:1

= 10:2

= 10:3

= 10:4

= 10:5

| **PHTHALO BLUE** | **+** | **PAYNE'S GREY** | | **FRENCH ULTRAMARINE** | **+** | **LEMON YELLOW** |

 = 10:1 = 10:1

 = 10:2 = 10:2

 = 10:3 = 10:3

 = 10:4 = 10:4

 = 10:5 = 10:5

GALLERY – BLUE

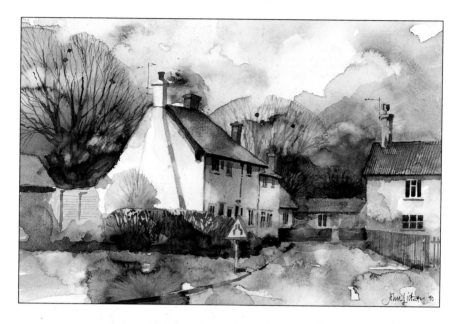

ABOVE *Cool blues and violet blues combine to create the impression of a cold winter's day. The sky was painted using mixtures of French ultramarine, phthalo blue, indigo and alizarin crimson. The foreground effects made use of indigo and aureolin (left) with Payne's grey, carmine and yellow ochre (right). The house shadows are ultramarine with a touch of indigo. (John Lidzey)*

RIGHT *This painting is of an old fireplace. The walls are blue grey and the fireplace is a faded white. The colours in the painting are a good match to the original. The colours have been built up in a series of weak overlaying washes using Payne's grey, ultramarine, cadmium yellow, carmine and yellow ochre. Each wash was applied only after the previous one had dried. (John Lidzey)*

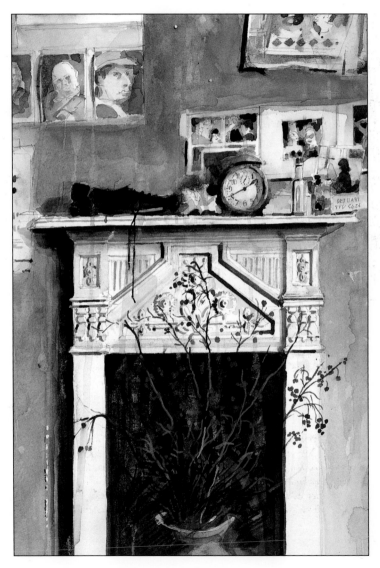

MIXING GREEN

There are relatively few proprietary watercolour greens produced, but it is not difficult to mix a wide range of greens from other colours and many watercolourists prefer to work without a single green in their palettes.

WARM GREENS

A green may be said to be warm when it is yellowish. It is even possible to mix a green that contains a certain amount of red, although the resulting colour will be rather dull and lacking in intensity. Warm greens can be mixed using cadmium yellow as a base and mixing this colour with cerulean blue produces a beautiful organic, if sometimes a somewhat patchy, green.

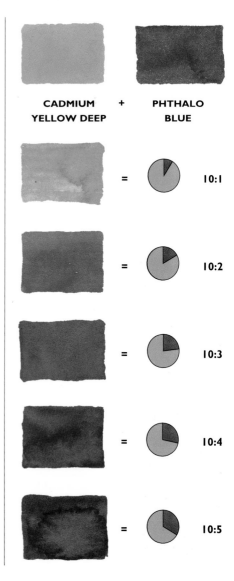

CADMIUM YELLOW DEEP	+	PHTHALO BLUE	
	=		10:1
	=		10:2
	=		10:3
	=		10:4
	=		10:5

GAMBOGE	+	CERULEAN BLUE			CADMIUM LEMON	+	FRENCH ULTRAMARINE

GAMBOGE + **CERULEAN BLUE** **CADMIUM LEMON** + **FRENCH ULTRAMARINE**

 = 10:1 = 10:1

 = 10:3 = 10:3

 = 10:5 = 10:5

 = 10:7 = 10:7

 = 10:10 = 10:10

MIXING GREEN

COOL GREENS

Hooker's green can be called cool (bluish) and sap green can be described as warm (yellowish). The intensity of both of these colours is impossible to match with mixing, especially the cooler Hooker's green. It is, however, often better to mix a lower intensity (duller) green from yellow and blue. Beautiful blue greens may be mixed from cool blues and yellows – lemon yellow and phthalo blue, for example, produce a wonderful cool green. Other possible combinations are shown here.

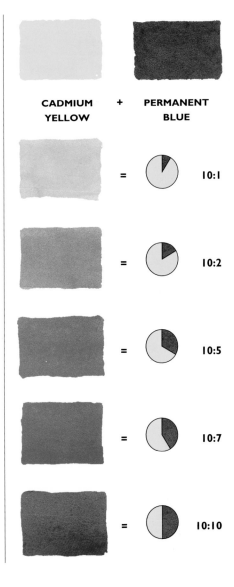

CADMIUM YELLOW	+	PERMANENT BLUE	
	=		10:1
	=		10:2
	=		10:5
	=		10:7
	=		10:10

| **LEMON YELLOW** | + | **MANGANESE BLUE** | | **AUREOLIN** | + | **INDIGO** |

 = 10:1 = 10:1

 = 10:2 = 10:2

 = 10:5 = 10:5

 = 10:7 = 10:7

 = 10:10 = 10:10

STILL LIFE – GREEN

This arrangement shows a number of lovely greens. Within the foliage the hues extend from the fresh yellow green of the conifer on the right to the mysterious, low-toned blue green of the euphorbia on the left. When you are painting the tones of the euphorbia the colours may be adjusted to light

13 French ultramarine
 6 burnt umber
 I aureolin
weak dilution

8 phthalo blue
7 indigo
3 lemon yellow
2 Payne's grey
strong dilution

II lemon yellow
 8 cobalt blue
 I Payne's grey
standard dilution

13 cadmium yellow
 2 French ultramarine
 5 manganese blue
standard dilution

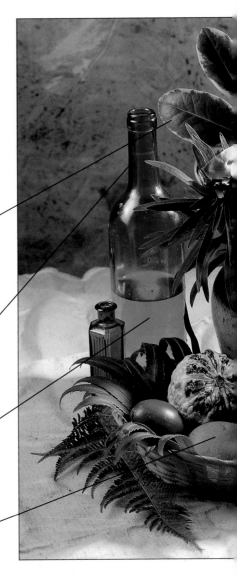

and dark by mixing additional water into the basic mixture for the lighter leaves or by adding Payne's grey for the ones in shadow.

The colour of the bottle on the extreme left of the picture is virtually the same as the colour of the liquid in the bottle next to it.

17 cadmium lemon
 2 indigo
 1 gamboge
standard dilution

12 manganese blue
 7 indigo
 1 aureolin
standard dilution

18 lemon yellow
 2 indigo
weak dilution

11 aureolin
 5 indigo
 3 phthalo blue
 1 cadmium yellow
 deep
standard dilution

MIXING BROWN

Browns can result when colours from opposite sides of the colour wheel are combined. When they are mixed most reds and greens will produce browns as often as red and blue will, in spite of orthodox theory. Try, for example, French ultramarine and cadmium red, which, mixed with a little water, will produce a brownish mixture.

WARM BROWNS

Cool browns are greenish and warm browns are reddish or yellowish. Good warm browns can be mixed using a base of yellow ochre. Using this colour with vermilion will result in a warm, sunny orangish-brown. Cadmium red with a small amount of indigo also results in a pleasing warm brown. Other combinations of colours are used here to show alternative results.

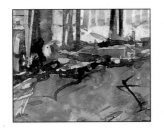

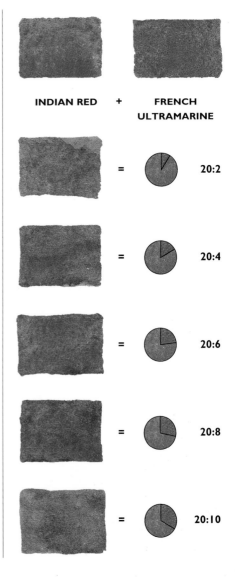

INDIAN RED **+** **FRENCH ULTRAMARINE**

= 20:2

= 20:4

= 20:6

= 20:8

= 20:10

YELLOW OCHRE	+	MAUVE		CADMIUM ORANGE	+	PERMANENT BLUE

 = 10:1 = 10:1

 = 10:2 = 10:2

 = 10:3 = 10:3

= 10:4 = 10:4

 = 10:5 = 10:5

MIXING BROWN

COOL BROWNS

Brown is an easy colour to mix. Sometimes an unintended brown will result when you are experimenting to mix another colour. When you are out on location, winter landscapes can be fascinating to paint using the wide variety of brown hues that can be mixed from a watercolour palette.

Reds and greens mixed will almost always produce a brown. Using more green than red usually results in a cool greenish-brown. Sap green and permanent red will produce a cool greenish-brown, as will viridian and cadmium red. Try also the combination of burnt umber and cerulean blue.

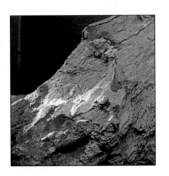

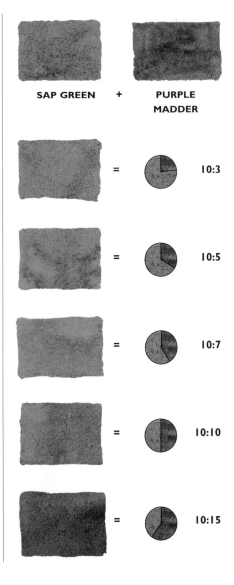

SAP GREEN + PURPLE MADDER

= 10:3

= 10:5

= 10:7

= 10:10

= 10:15

SCARLET + **PAYNE'S GREY**
VERMILION

VIRIDIAN + **CADMIUM RED**

 = 10:3

 = 10:1

 = 10:5

 = 10:3

 = 10:7

 = 10:5

 = 10:10

 = 10:7

 = 10:15

 = 10:10

STILL LIFE – BROWN

This arrangement shows a subtle range of colours from pale yellow browns through to rich, cool blue browns. The warmest colour is shown in the halo of the lit candles, and it is almost exactly the same as the colour of the rim of the jar on the right. The coolest brown is found at the bottom

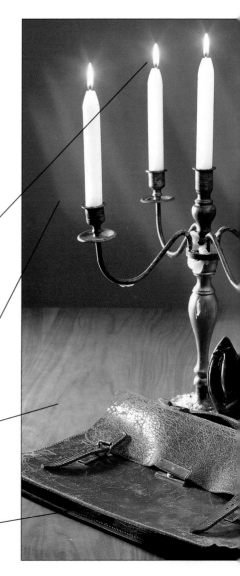

14 **cadmium yellow deep**

6 **cadmium red**

trace of French ultramarine

standard dilution

7 **burnt umber**

7 **French ultramarine**

2 **Winsor red**

4 **yellow ochre**

strong dilution

11 **cadmium red**

3 **cobalt blue**

3 **cadmium yellow deep**

3 **yellow ochre**

standard dilution

11 **carmine**

4 **indigo**

3 **cadmium yellow deep**

2 **French ultramarine**

strong dilution

of the briefcase which contains some violet in the mix.

Many proprietary brown and brownish colours are avaiable from art stores, but for the purposes of this demonstration most of the hues of brown have been made up from other colours.

15 yellow ochre
2 cadmium red
3 Payne's grey
very weak dilution

16 vermilion
3 yellow ochre
1 French ultramarine
standard dilution

11 carmine
5 indigo
3 cadmium yellow deep
1 French ultramarine
weak dilution

10 alizarin crimson
5 French ultramarine
2 cadmium yellow deep
3 yellow ochre
standard dilution

GALLERY – BROWN

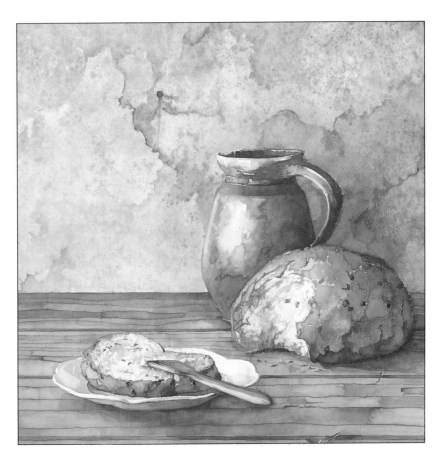

ABOVE The range of subtle browns in this lovely still life by Crin Gale
was created with just a few earth colours plus violet and blue. The
bread was painted in mixtures of raw and burnt sienna and burnt
umber, the jug in burnt umber and alizarin carmine, while the
background was painstakingly built up from cobalt blue, raw sienna,
Indian red and burnt sienna.

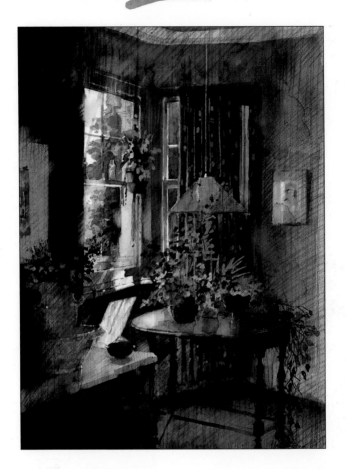

ABOVE The cool blues in this painting provide a contrast to the brown of the walls, furniture, curtains and floor. These browns were mixed from yellow ochre, cadmium red, Payne's grey and French ultramarine with thin washes of indigo over the top. Because especially low-toned colours were required, a cross-hatching of black Conté crayon was laid over all of the shadow areas. (John Lidzey)

MIXING GREY

Mixing a true black from just two watercolour hues is impossible, yet mixtures of three or more colours in sufficient density can produce a near black, although it will not have the quality of an ivory black. For example, vermilion, ultramarine and cadmium yellow can be combined, with a little water to produce an effective greenish-black. A number of warm and cool greys can be produced by mixing two watercolour hues together.

WARM GREYS

Warm greys will result from mixing earth colours with blues. The warmth of the blue will affect the warmth of the resultant grey. Careful mixing is required. If you use too much earth colour the "grey" will become a brown.

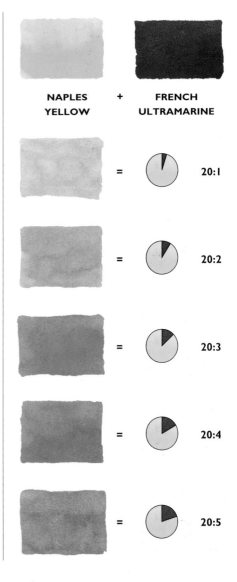

NAPLES YELLOW + **FRENCH ULTRAMARINE**

= 20:1

= 20:2

= 20:3

= 20:4

= 20:5

BURNT UMBER + COBALT **WARM SEPIA + CERULEAN BLUE**

 = 10:1 = 10:1

 = 10:3 = 10:3

 = 10:5 = 10:5

 = 10:7 = 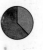 10:6

 = 10:10 = 10:7

MIXING GREY

COOL GREYS

Like warm greys, the best cool greys come from a combination of blues and earth colours, although complementary colours, such as viridian and purple madder, will sometimes combine to make a good cool grey.

The proprietary colour neutral tint can also be warmed or cooled with reds and blues to make a satisfying range of greys. Some alternative mixes are suggested here.

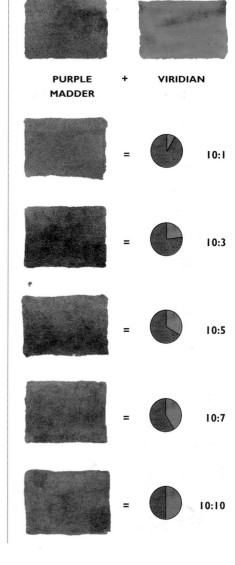

PURPLE MADDER **+** **VIRIDIAN**

= 10:1

= 10:3

= 10:5

= 10:7

= 10:10

	+				

YELLOW OCHRE	**+**	**FRENCH ULTRAMARINE**	**BURNT SIENNA**

PHTHALO BLUE

 = 10:1

 = 10:1

 = 10:4

 = 10:2

 = 10:5

 = 10:3

 = 10:6

 = 10:4

 = 10:8

 = 10:5

A

acrylics 14–19
alizarin crimson 70–1, 84–6, 92–3, 106–7, 113, 119, 124, 131, 138, 140–1, 146–8, 152
aureolin 124, 133, 161

B

black 38
 and colour value 6–7, 10
blue 8–9, 20–5, 52–5, 152–7
 lightening and darkening 74–5
 warm and cool 152–5
bright green 48, 50
brightness 7, 12–13
brown 10, 36, 38, 56–61, 106, 110–16, 164–71
 warm and cool 164–7
burnt sienna 18, 36, 56, 84–5, 175
burnt umber 70, 80–1, 125, 166, 173

C

cadmium green 70, 100–1, 110–11
cadmium lemon 154, 159
cadmium orange 19, 36–8, 52–3, 57, 62–3, 132, 165
cadmium red 12, 19, 36–9, 42–3, 48–9, 57, 62–3, 70–1, 75, 84–6, 92–3, 106, 110–12, 118–19, 124, 139, 164, 166–7
cadmium yellow 6–7, 12, 19, 26–7, 32–3, 36–7, 44–5, 62, 70–1, 74, 80–1, 84, 92–3, 96, 99, 110, 124, 126, 132, 138, 158, 160, 172
carmine 70, 87–9, 108–9, 133, 140, 146, 148–9
cerulean blue 18, 20, 52, 75, 96–7, 107, 125, 140–1, 152, 154, 158–9, 166, 173
cobalt blue 20, 127, 152–4, 173
cobalt green 139
cobalt violet 70, 87
complementary colours 8, 44–55, 62, 110–11, 118
cool colours 20, 110, 118, 126, 140, 148–9, 154–5, 160–1, 166–7, 174–5
crimson lake 139

D

Davy's grey 153
dilution 122

G

gamboge 127, 159, 163
geranium red 87

granulation 122, 125
grey 12–13, 62–5, 106, 110, 112, 117–21
 warm and cool 172–5
green 8–9, 26–31, 48–51, 96–104, 158–63
 warm and cool 158–61

H

Hooker's green 160
hue 6–9

I

Indian red 164
Indian yellow 126, 131
indigo 149, 161–4
ivory black 70, 98–9

L

lemon yellow 18, 34, 44, 70–1, 80–1, 92–3, 97, 113, 118, 127, 131–3, 155, 160–1

M

magenta 86, 108–9
manganese blue 149, 161–3
mauve 143, 149, 165

N

Naples yellow 172

O

oils 66–71
olive green, pale 18, 29, 48, 65
orange 8–9, 36–7, 52–5, 91–5, 130–7

P

Payne's grey 10, 18–19, 26, 36, 38, 57, 70–1, 96–7, 127, 155, 167
permanent blue 153, 160, 165
permanent rose 19, 32, 38, 42, 48, 70, 86, 106–7
permanent violet 18
phthalo blue 19–21, 26–7, 52–3, 124, 140, 142, 147–8, 152, 155, 158, 160, 162–3, 175
phthalo green 12, 18–20, 32, 49, 62–3
pink 10, 38, 84, 86–7
pointillism 31
primary colours 8–9, 110, 112–13
Prussian blue 148, 152
purple madder 142, 147, 166, 174

R

raw sienna 33, 56
raw umber 35, 70–1, 73, 80–1, 125, 154

red 8–9, 38–41, 48–51, 84–90, 138–45
 lightening and darkening 84
 warm and cool reds 138–41
rose madder 140

S

sap green 70, 99–100, 166
saturation 6–7, 12–13, 44
scarlet lake 140–2
secondary colours 8–9, 110
sepia 173
shades 10
space and depth 10

T

terre verte 101
tints 10, 12
titanium white 19, 70–1
tone gradation 10–11

U

ultramarine 19–21, 26–7, 42–3, 53, 62–3, 70–4, 96, 106–7, 112–13, 118–19, 125, 140, 146, 152, 154–5, 159, 164, 172, 175

V

value 6–7, 10–11
venetian red 87
vermilion 125, 130, 132, 139, 153–4, 164, 167, 172
violet 8–10, 42–7, 105–9, 146–51
 warm and cool 146–9
violet, deep 19–20, 39, 42–5, 62
viridian 73, 110–11, 119, 166–7, 174
visual gaps 8–9

W

warm colours 20, 110, 126, 138, 146–7, 152–3, 158–9, 164–5, 172–3
watercolours 122–5
wheel, colour 8–9
white
 and colour value 6–7, 10
Winsor red 131, 133, 138, 147
Winsor violet 70–1, 80–1, 108, 110, 118

Y

yellow 6–10, 32–5, 44–7, 70–1, 79–83, 126–9, 136–7
yellow ochre 10, 18, 32, 36, 72, 80–1, 98, 113, 125, 130, 164–5, 175